THEN & NOW

MEDFORD

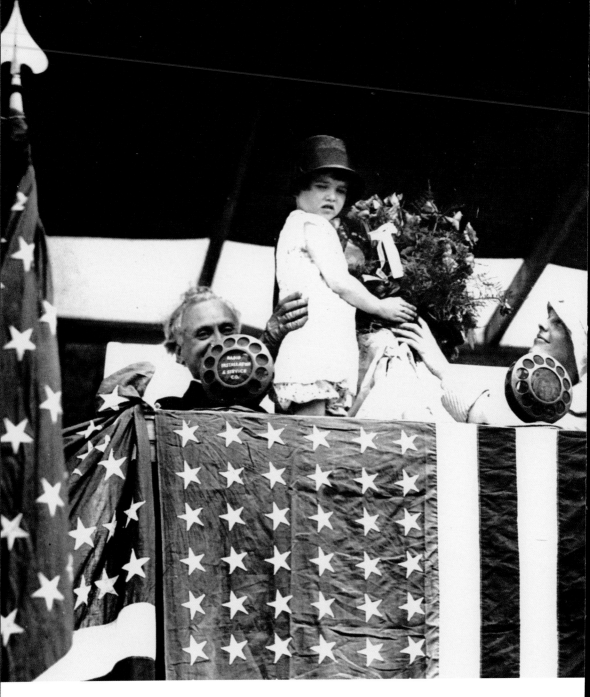

In 1924, Amelia Earhart and her mother moved to Brooks Street in West Medford. Earhart's sister, Muriel Morrissey, was a teacher in Medford and lived to be 98 years old. In this photograph, dated July 1928, Mayor Edward Larkin welcomes Amelia Earhart home after her Atlantic flight. Regina O'Hearn, Mayor Larkin's granddaughter, is pictured presenting Earhart with a bouquet of roses. Regina, reluctant to give up the flowers, had to be coaxed by her grandfather to hand them to Earhart. (Courtesy of Regina MacDonald.)

THEN & NOW

MEDFORD

Patricia Saunders

ARCADIA
PUBLISHING

Published by Arcadia Publishing
Charleston, South Carolina

Printed in the United States of America

Library of Congress Catalog Card Number: 2005927374

For all general information contact Arcadia Publishing at:
Telephone 843-853-2070
Fax 843-853-0044
E-mail sales@arcadiapublishing.com
For customer service and orders:
Toll-Free 1-888-313-2665

Visit us on the Internet at www.arcadiapublishing.com

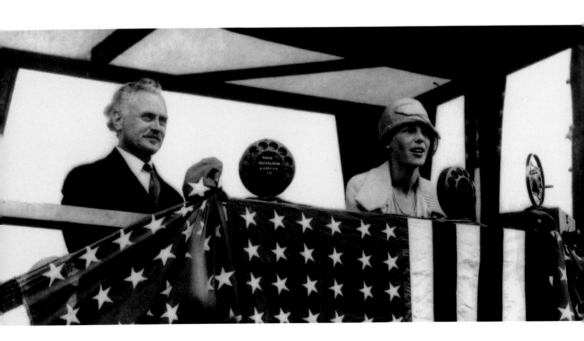

Mayor Edward Larkin and Amelia Earhart are shown here at the opening celebration of her homecoming on July 10, 1928. This photograph was taken at the high school athletic field on Fulton Street. Gillis Field is now home to the North Medford Little League. (Courtesy of Jean MacDonald.)

CONTENTS

ACKNOWLEDGMENTS

It is with sincere appreciation that I thank the Medford Historical Society, especially curator Michael Bradford and Ryan Haywood, for all their help in gathering photographs and material for this book. I would also like to thank the following people who helped me along the way—it is true that you can get by with a little help from your friends: Jay Griffin, president of the Medford Historical Society; Barbara Kerr from the Medford Public Library; Dee Morris; Rob Dilman; Helena Gingras; Nancy Collins; Marianne McCarthy; Jeff and Julie Saunders; Peter Saunders; David Saunders; Margaret McCarthy; members of Medford Arts Center, Inc.; Mayor Michael McGlynn; Tom Convery; the Royall House Association; Medford Brooks Estate Land Trust; Medford Chamber of Commerce; Delores Carroll; Massachusetts Cultural Council; Medford Arts Council; Michael and Sean from the one-hour photo lab at Costco; Deanna and Claudette from CVS one-hour photo; Maia Henderson; and Doug Carr. To my family and relatives, a thanks for all the childhood recollections: Larry Lepore; Barbara Lepore; Jean MacDonald; John MacDonald; Janet O'Hearn; Marie Collins; Faith Belluche; my mom, Margaret McCarthy; my brother, Joe McCarthy; Ed McCarthy; Bob McCarthy; the late Ted O'Hearn; Brad Collins; Mark Egitto; Betty King; and especially my father, Joseph F. McCarthy.

Photographs of the Peter Chardon Brooks Home and the Shepherd Brooks Estate were from the collection of Maia Henderson. Except where otherwise noted, the author, Patricia McCarthy Saunders, took all of the contemporary photographs.

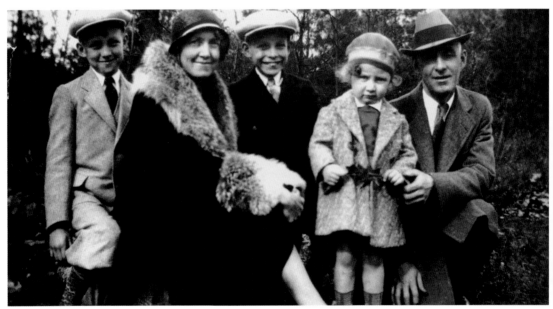

The McCarthy family is pictured here c. 1930. From left to right are: Ed McCarthy, Nora McCarthy, Joe McCarthy, Robert McCarthy, and James McCarthy.

INTRODUCTION

Medford, Massachusetts, is one of the oldest settlements in North America. Founded in 1630 by Gov. Matthew Cradock, Medford began as a seaport town famous for building clipper ships and exporting rum. In 1636, the building of the Cradock Bridge began and in 1668, the Peter Tufts Cradock house was built. On April 19, 1775, Paul Revere made the first stop of his famous ride in Medford at the home of Capt. Isaac Hall. In 1789, President Washington visited Gen. John Brooks. Thatcher Magoun established the shipyard industry in 1803. Tufts College opened in 1854 under the leadership of Rev. Hosea Ballou. In 1870, Medford's first public water supply from Spot Pond was introduced and by 1892 Medford received her charter as a city.

Medford is known for many of its famous residents. The aviator Amelia Earhart, anti-slave activists Lydia Maria Child and Prince Hall, cookbook author Fannie Farmer, and "Jingle Bells" composer James Pierpont,

One of the more interesting facts about Medford is the manufacturing of rum for nearly 200 years. It began in 1715 and ended in 1905, when the Lawrence family closed the distillery on Riverside Avenue. John Hall built the original distillery, and sold it to his brother, Andrew, who continued the business until his death in 1750. On that same site, Benjamin, Andrew's son, made rum until 1803. Bottles of old Medford rum are on display at the Medford Historical Society on Governor's Avenue.

Medford is well known for its architectural richness, and its Colonial, Victorian, Federal, and Greek Revival style buildings and homes. One particular "gem in the rough" is the Shepherd Brooks Estate and carriage house. Built in 1880, the manor is a Queen Anne–style mansion built of brick and granite, with a red slate roof. In 1993, a group of Medford citizens formed the Brooks Estate Preservation Association as a successor to the Medford Brooks Estate Land Trust. In modern times, the manor is undergoing restoration after years of neglect.

One of the little known facts about Medford's past is that the film producing studios of Fulton Heights were located there in the early part of the 20th century. High on top of the hill across from Wright's Pond was what was called the Glass House. It was a huge, three-story structure built of cement blocks and glass, and was topped with a glass roof to capture sunlight. It was an ideal spot for making movies. Tom Brown, of *Tom Brown's School Days*, made his first movies here. At the lower end of the property was a small, attractive brick building where rum was also made. In 1938, after years of disrepair, the Glass House burned to the ground, possibly by arson. So, for a brief time, Medford could have been considered the "Hollywood of the East."

In 1896, the Medford Historical Society was organized by a group of concerned citizens who were interested in preserving the history of the city. The first headquarters, located at 2 Ashland Street, was a historic house built in 1800, and was the birthplace of Lydia Maria Child. Her father, Convers Francis, originated the famous Medford cracker. The historical society sold that property in 1915, and moved to rented quarters at 6 Main Street. In 1916, they built their present headquarters on Governor's Avenue The president at the time, Moses W. Mann, designed the Spanish Mission style building. One of the historical society's first projects was to sponsor a historical festival, On the Banks of the Mystic, in 1896. In 1930, a colossal production of a *Pageant of the Mystic* was performed

at the Shepherd Brooks Estate, which capped the 300th anniversary of the founding of the city. In 1976, during the bicentennial celebrations, a revised production of this pageant was performed at the Chevalier Auditorium by a group of Medford citizens called the Mystic Players. Today the Medford Historical Society continues to present Medford's rich history to residents through special exhibits and programs. In recent years there has been a growth in interest of arts and culture in the city. For several years, local artists have organized and hosted many events and exhibitions all over the city. The West Medford Open Studios and the Mabray "Doc" Kountze Festival are two events that are held every year. Two years ago, the new facility Springstep, a multicultural performing arts center, opened in Medford. It offers a variety of programs to the public.

Medford has been designated a Tree City USA, and was the recipient of the Massachusetts Governors Award for Open Space. In January 2004, Mayor McGlynn created the Medford Clean Energy Committee (MCEC) to augment the city's effort to become a municipal leader in the use of clean power. Elizur Wright, the father of the Middlesex Fells, was one of the organizers of the fells, and would be proud of the citizens of Medford today for their effort in continuing the preservation of local areas.

Medford residents have a great interest in the rich history of their city, as is evident by the turnout at local historic and artistic events. Through this book, residents may view captivating images that document the changes that have taken place in Medford over the last 100 years.

This 1905 photograph of the 4th, 5th, and 6th grades of the city was taken at the Opera House on Friday, June 16th at 2:00 p.m. Over 1,000 children with banners flying and flags waving filled the auditorium in celebration of Medford's 275th anniversary. Mayor Dwyer gave a few words of welcome, and was followed by a program of entertainment. Afterwards, the schools sang "Flag of our Native Land" and "Maryland! My Maryland." (Courtesy of the Medford Historical Society.)

Chapter 1

THEATERS

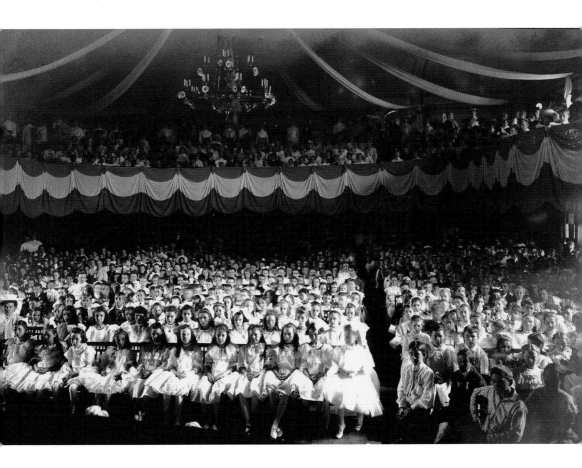

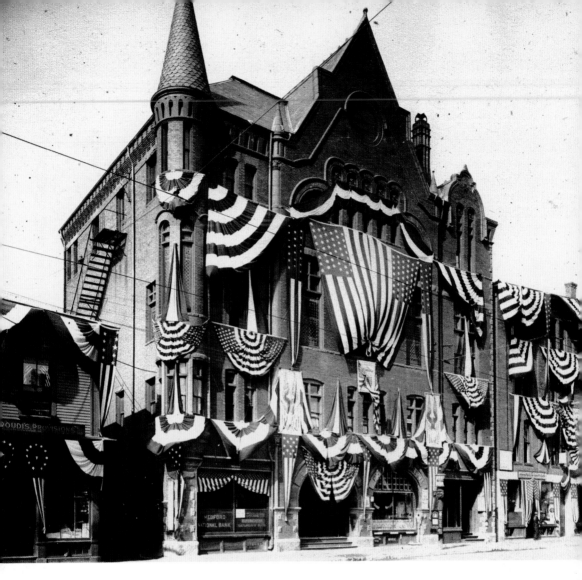

The Opera House was erected in 1886 in Medford Square. In the auditorium, plays, lectures, banquets, minstrel shows, town meetings, and even roller-skating workouts were hosted. It is said that the first moving picture show was presented here before the Medford Theatre opened on Salem Street in 1915. The building was destroyed by fire in November 1911. Today Medford Optical, Joe's Fine Wine and Spirits, and the Lighthouse Café occupy the first floor of the building.

Shown in this early 19th century photograph is an inside view of the Opera House as seen from the stage. A fire in 1911 destroyed most of the interior. The 1981 photograph shows what remains of the southeast section of the Opera House. It is particularly fascinating that this portion of the Opera House still stands. (Contemporary photograph by Michael Bradford.)

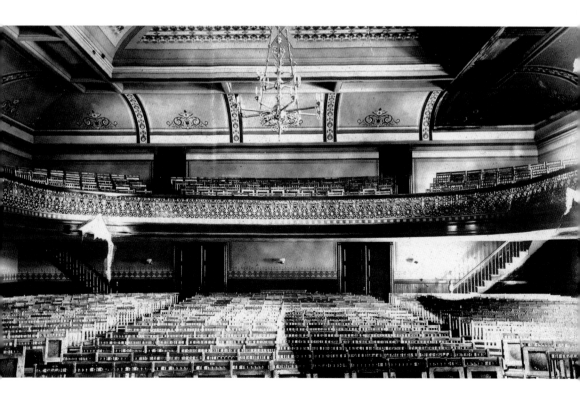

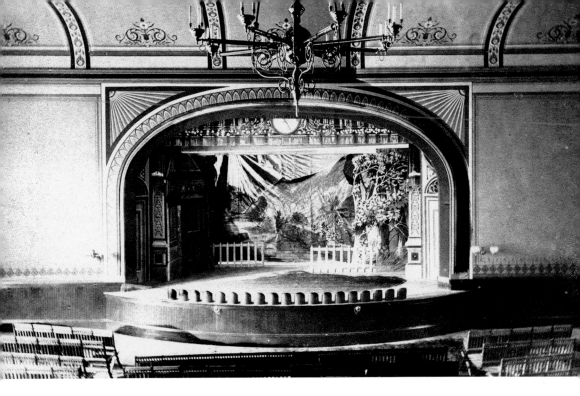

In this vintage photograph, the view of the Opera House stage from the balcony can be seen. At the time, the building housed a soda fountain, clubrooms, and offices, and had a seating capacity of close to 1,000 patrons. The current photograph is a view looking south to the stage, with the proscenium arch visible. (Contemporary photograph by Michael Bradford.)

In 1917, the Society Players Film Company was the third movie company to locate in the Wright Pond's area of North Medford. The company occupied the building once known as the "Old Pest House" on the corner of Elm Street and Aquavia Road. Today it is a private home. This vintage photograph was taken between 1884 and 1890. (Courtesy of Tom Convery.)

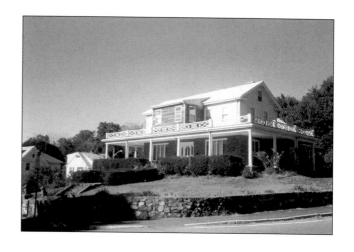

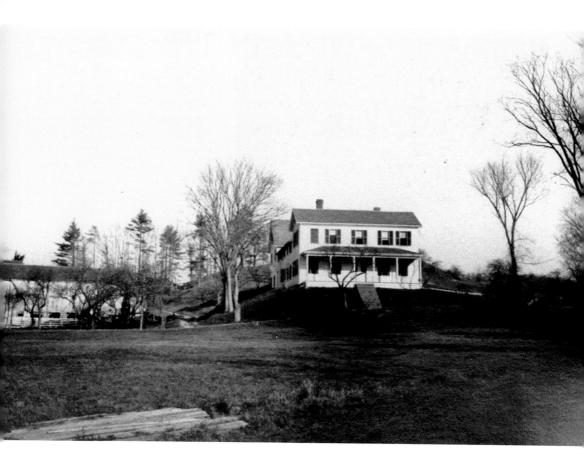

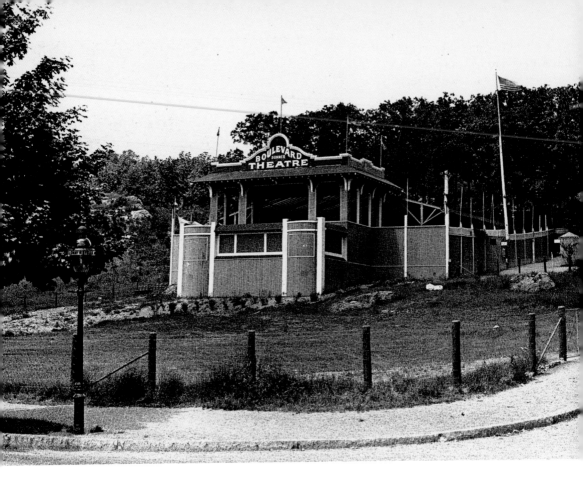

The J. W. Gorman Boulevard Theatre was located on the corner of Fells Avenue and Fellsway West. During the early 1900s, this outdoor summer theater extended all the way down to the Haines Square area on Spring Street. It seated 1,800 people—1,200 in 25¢ seats, 300 in 20¢ seats, and 300 in 10¢ seats and benches. (Courtesy of the Medford Historical Society.)

Many film companies were once located in North Medford. These companies included the Humanology Film Company on Fulton Street, Mastercraft Photoplay on Elm Street, Holman Day Movie Plant on Elm Street, Worthy Pictures Corporation on Elm Street, and Filmland City located by Wright's Pond. In May 1919, films were produced in both Los Angeles and Medford, and shown at the Medford Theatre. In 1921, a two-reel detective story, adapted from a Nick Carter novel, was the first film produced at Filmland City and starred Tom Carrigan. Over the years, financial problems and litigations caused the film industry in Medford to dissipate.

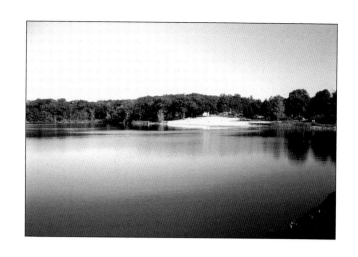

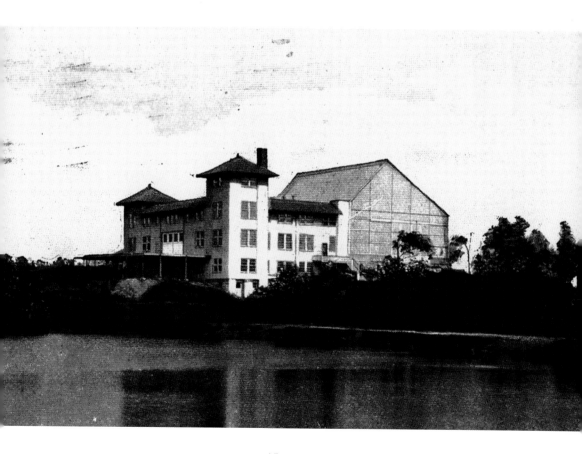

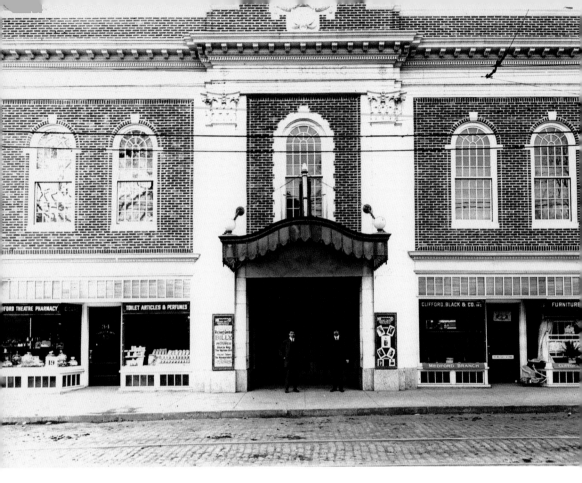

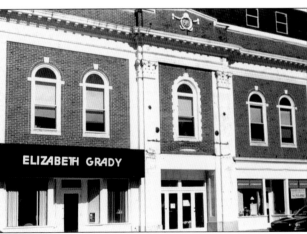

The Dyer Building at 36 Salem Street was built in 1915 and was once the home of the Medford Theatre. This theater was built to show films produced right in the city. By 1983, the movie theatre closed. Today the Elizabeth Grady Salon occupies the building. This was also once the site of the old Withington Bakery, famous for its Medford cracker. (Courtesy of the Medford Historical Society.)

This vintage photograph shows the Medford Square Theatre, not to be confused with the Medford Theatre across the street. There were two entrances to this theater, one on Salem Street, as shown in this photograph, and one on Riverside Avenue. Elizabeth Short, known as "The Black Dahlia," worked here when she was in high school. She was murdered in California in 1947, and the crime was never solved. The theatre closed in the mid-1950s.

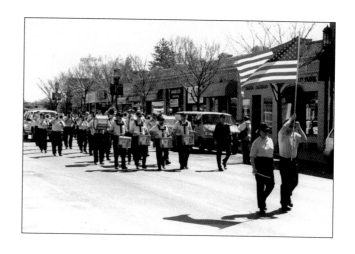

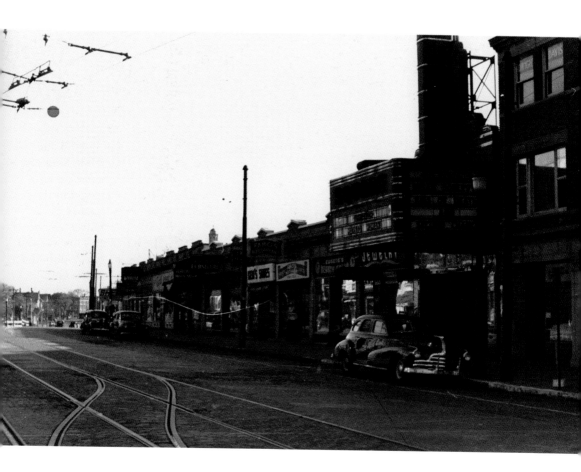

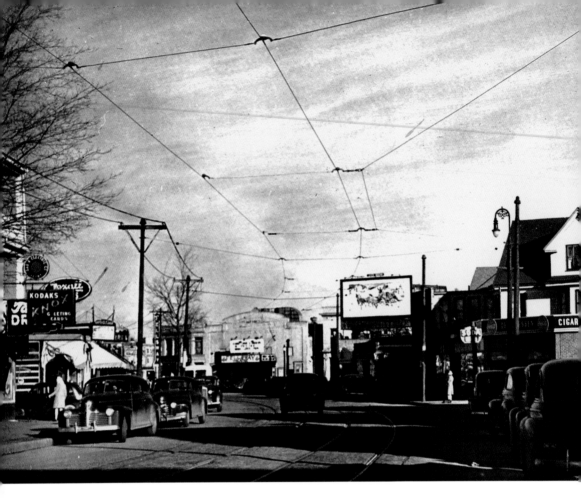

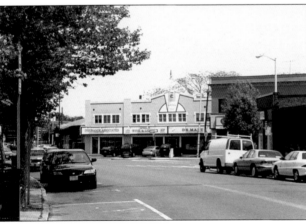

The old Fellsway Theatre in Haines Square was built around 1916, on the corner of Salem and Spring Streets. This was another theater built to showcase local films being produced in Medford. Tom Convery, of the Salem Street Business Association, was an usher here when he was in high school. He recalls seeing the movie *Gone With the Wind* over 20 times. The theater closed for good in the late-1950s.

Al Lane's Café was a favorite spot to lunch for anyone wanting to catch a glimpse of the actors in town. Years later, the restaurant became the Medford Café, a popular establishment during the 1930s and 1940s. Today the building located at 15 High Street is Congressman Ed Markey's district office.

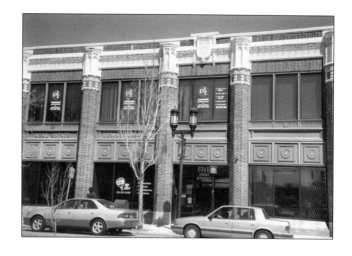

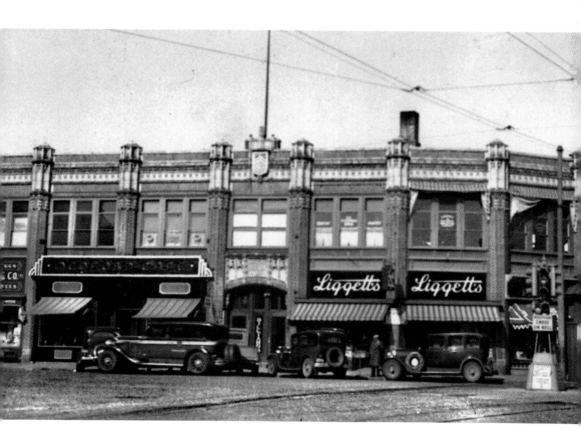

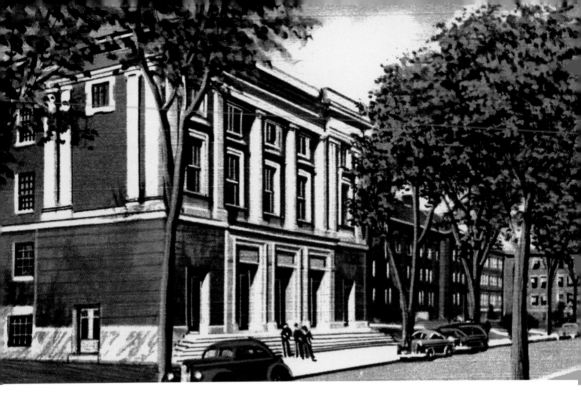

The Chevalier Theatre on Forest Street was named in honor of Lt. Comdr. Godfrey de Chevalier, a pioneer naval aviator. Chevalier graduated from Medford High School in 1906. He was appointed a Navy air pilot in 1915, and died in 1922 at the Naval Hospital in Norfolk, Virginia. Today volunteers from the Friends of Chevalier, Mystic Players, Gene Mack Gymnasium, and many others, spend countless hours raising funds and promoting the theater with stage productions and concerts. (Vintage photograph from the Medford Historical Society.)

At the end of the 19th century, two racetracks, Mystic Park and Combination Park, were located in South Medford. Race-goers would arrive in Medford and often stay at the Medford House on Main Street. Mystic Park was sold for development in 1903, and Combination Park closed in 1901. Many of the streets in that neighborhood were named for the owners of the horses that raced at the park. During the 1930s, there was a car-racing track that extended from where the Meadow Glen Mall now stands to the Wellington Circle area.

Chapter 2

SOUTH

MEDFORD

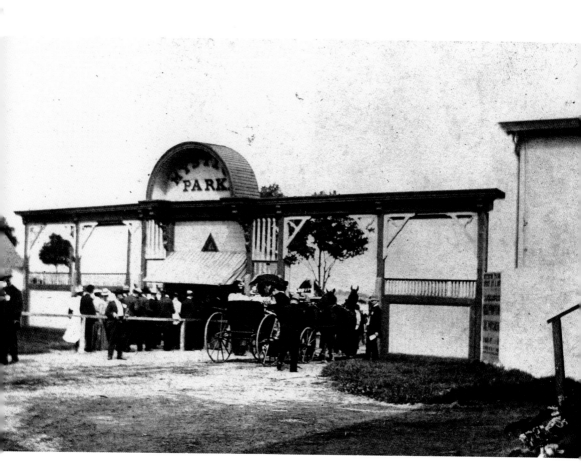

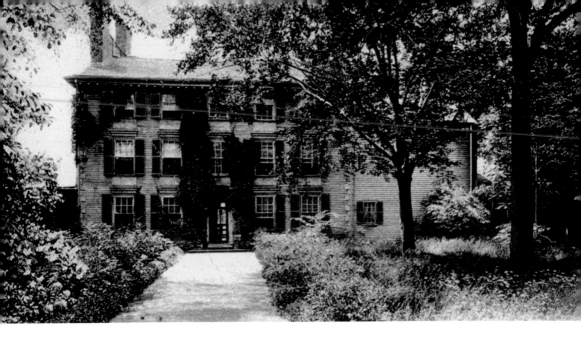

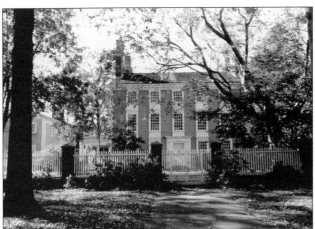

In 1737, slave trader and rum distiller Col. Isaac Royall Jr. lived at the Royall House on the corner of Main and George Streets. He inherited the estate after the death of his father in 1734. This house was one of the most expensive homes in Medford. His father, Isaac Royall Sr., designed it after the model of an English noblemen's house in Antigua. At the outbreak of the American Revolution, the property was seized by patriots and is believed to have been the headquarters for Generals Lee and Stark. Today it is one of New England's finest Colonial mansions and a National Historic Landmark.

The small brick-and-clapboard building on the grounds of the Royall House is the only extant slave quarters in the northern United States. The Royalls brought 27 slaves from Antigua to run their estate in Medford. Several of their slaves became prominent members of the Medford community. Every year between May and October, hundreds visit the Royall House and the slave quarters. (Courtesy of the Medford Historical Society.)

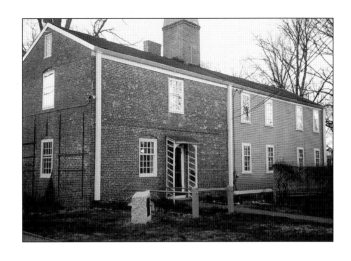

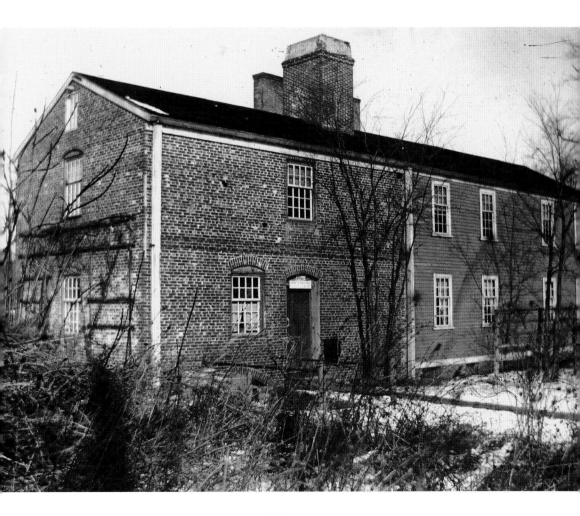

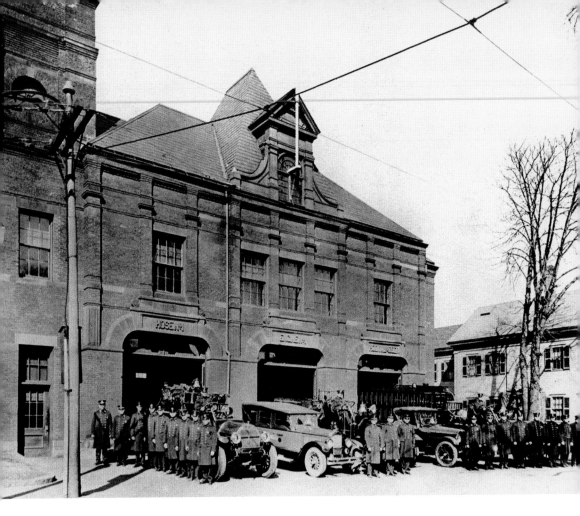

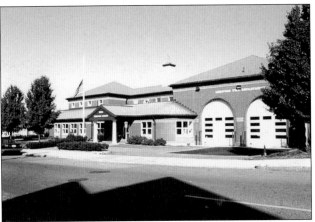

The Medford Fire Department was established in 1839. Today the fire department is trained and equipped with the latest technology, including self-contained breathing equipment, defibrillators, and radios. The vintage photograph shows the South Medford firehouse in 1926, and the modern photograph shows the fire station today.

The Medford Police Department was organized in 1870. This vintage photograph shows the police headquarters on the corner of Main and Swan Streets in 1894. Today at 90 Main Street, the Medford police offer a variety of programs for local residents. These include community meetings held once a month at the academy. The DARE program is also used to educate children of all ages. (Courtesy of the Medford Historical Society.)

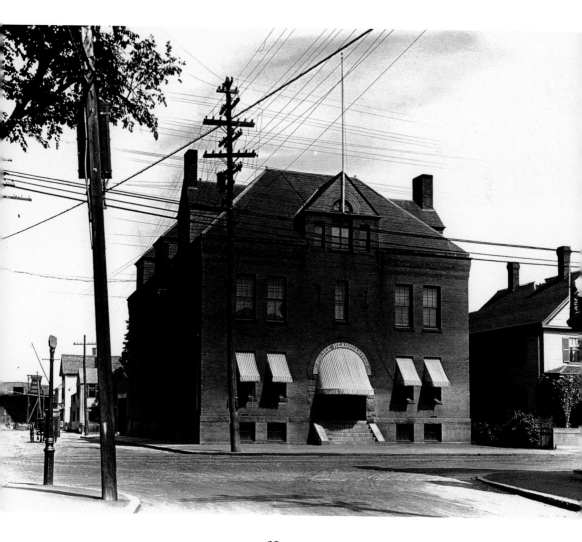

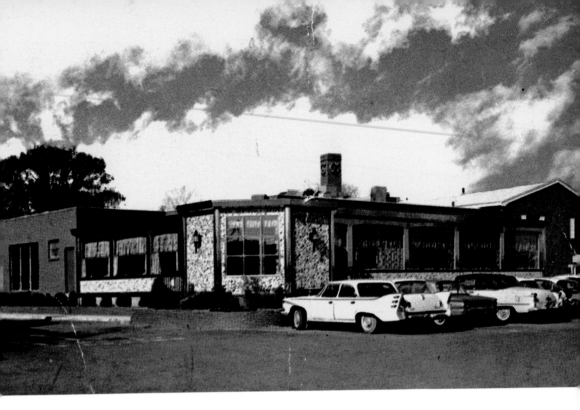

Carroll's Diner, a sadly missed restaurant in Medford, was located where the old Medford House, a famed Colonial tavern, once stood. Carroll's Diner originated as a classic diner car, and later became a restaurant that offered elegant dining and function rooms. The diner closed in the late 1980s. Today a medical facility is located at the site on 101 Main Street. (Courtesy of Delores Carroll.)

Ballou Hall, built from 1852 to 1853 on the summit of College Hill, was named for Rev. Hosea Ballou, the first president of Tufts College. Reverend Ballou was inaugurated in 1853, and served until his death in May 1861. He was from Medford and was minister of the First Universalist church. His great uncle, also named Hosea Ballou, was the father of American Universalism. Medford considered it a great honor to have Reverend Ballou as its first president of Tufts College.

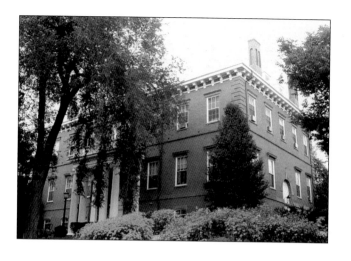

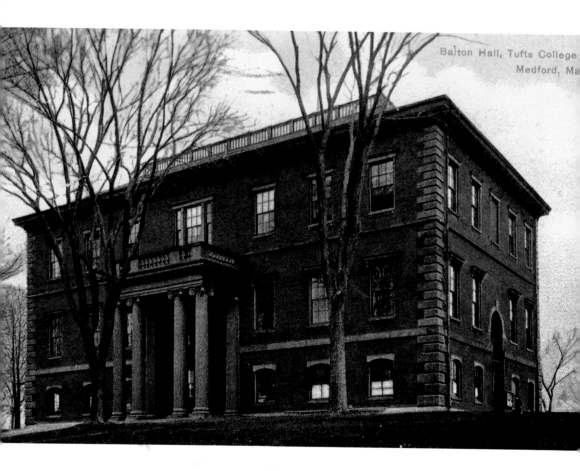

Balton Hall, Tufts College
Medford, Ma

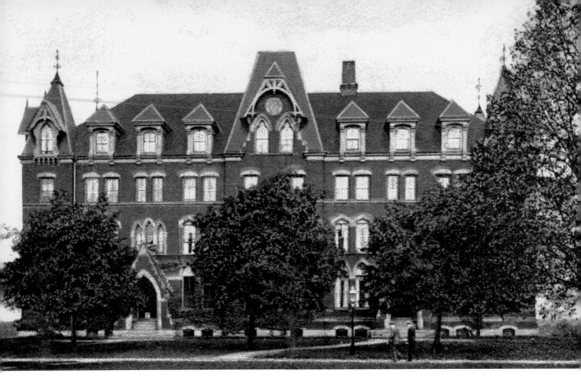

West Hall, located at the top of Walnut Hill on the campus of Tufts University, opened its doors to students in 1872. West Hall, along with Ballou Hall, Barnum Hall, Goddard Chapel, and Paige and Minor Hall, make up the quadrangle of buildings on the hill. West Hall, East Hall, and Dean Hall were the dormitories for male students. Metcalf Hall and Start Hall were for the female students. (Courtesy of the Medford Historical Society.)

The Goddard Chapel at Tufts University was built in 1884. Mart T. Goddard donated it in honor of her husband, Thomas A. Goddard, a former benefactor of the college. Thomas Goddard, a wealthy merchant and once the treasurer of Tufts, quietly gave funds from his own pocket to keep the college out of debt. The style of the chapel is Romanesque with a Lombardic tower. Its beautiful setting makes it a popular location for weddings, especially in the spring and fall.

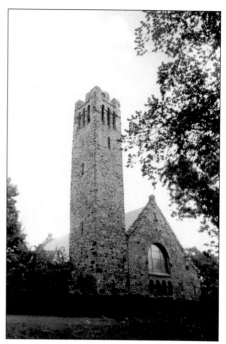

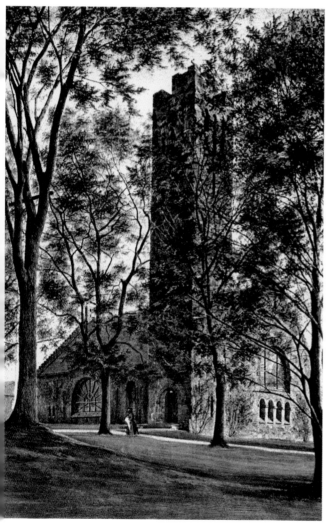

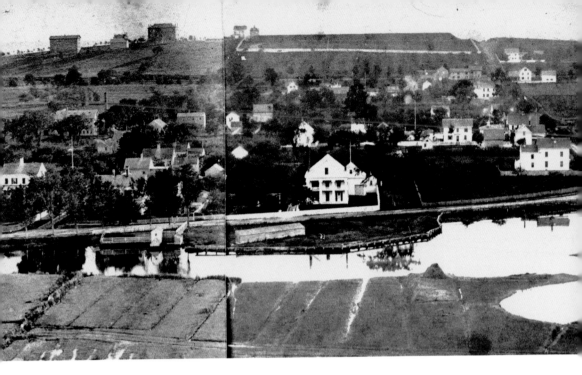

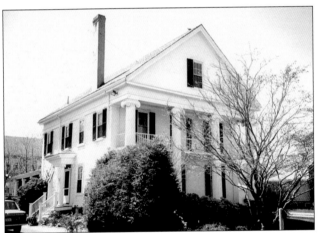

Paul Curtis, a shipbuilder on the banks of the Mystic River, built this Greek Revival home in 1839. Curtis built 27 vessels on this property. It is believed that the home was the inspiration for the poem "Over the River and Through the Woods," by Lydia Maria Child. The home is listed on the National Register of Historic Places.

The Peter C. Brooks III estate, known as Point of Rocks, was built by Peter Chardon in 1859. Peter Chardon was the grandson of Peter Chardon Brooks, who was the wealthiest man in New England in the 1830s. In 1870, a cottage was built on the property, and parts of it still remain today as a private residence. Point of Rocks was demolished by the city of Medford in 1946. Sarah Lawrence Brooks took this vintage photograph in July 1885. (Courtesy of Maia Henderson.)

Chapter 3

WEST MEDFORD

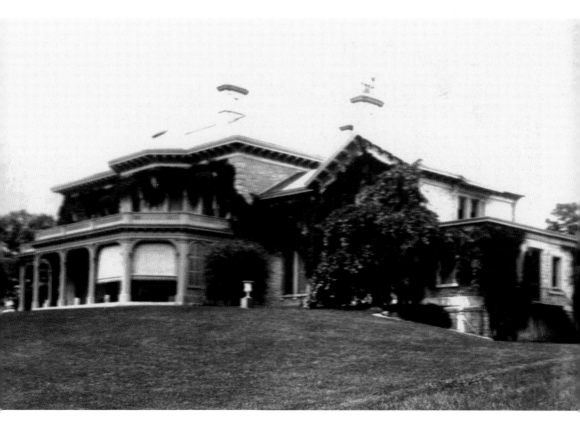

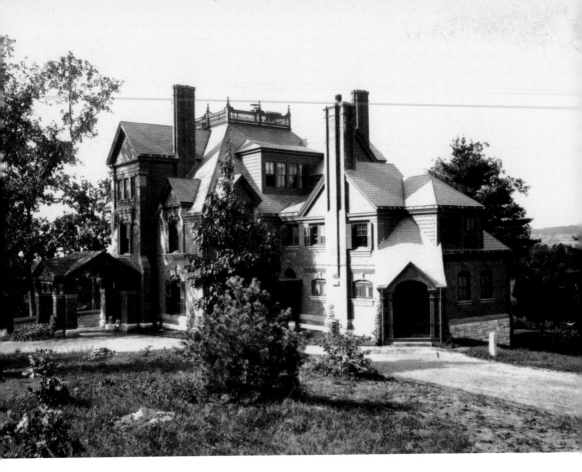

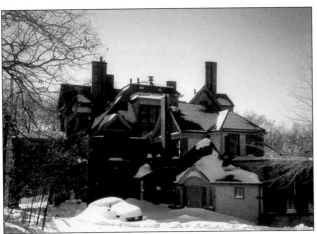

The Shepherd Brooks Estate, located in the northwest corner of the city at 275 Grove Street, consists of 50 acres of woods, ponds, wetlands, and two Victorian structures, a manor and carriage house. Shepherd Brooks hired the firm of Peabody and Stearns to design his summer home. From 1946 to 1954, the manor was part of Brooks Village, which provided housing for veterans. In the 1960s and 1970s, it was used as a nursing home. Caretakers now occupy the manor. The entire estate is on the National Register for Historic Places and was awarded a national American treasure designation in 1999.

Between 1884 and 1889, Shepherd Brooks transformed the landscape of his estate by creating Brooks Pond. For many decades, this picturesque pond has been a popular place for ice-skating. In June and July of 1930, during Medford's tercentenary celebration, Clara Brooks (Shepherd's wife) hosted the *Pageant on the Mystic*. Visible in the vintage photograph is the Medford seal that was used on the pageant's stage. (Courtesy of the Medford Historical Society.)

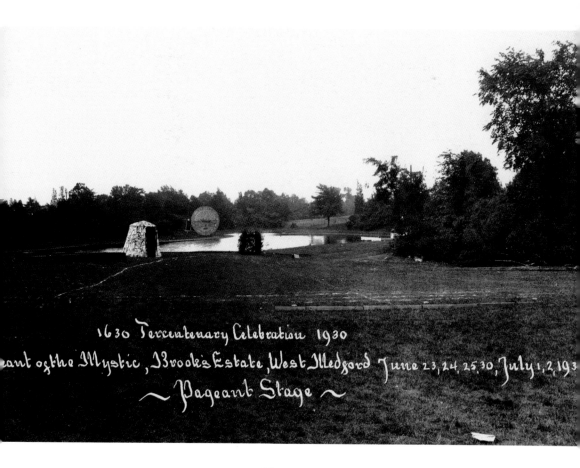

1630 Tercentenary Celebration 1930
eant of the Mystic, Brooks Estate, West Medford June 23, 24, 25, 30, July 1, 2, 193
~ Pageant Stage ~

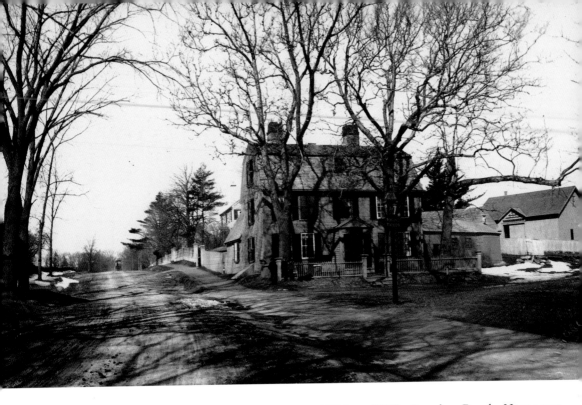

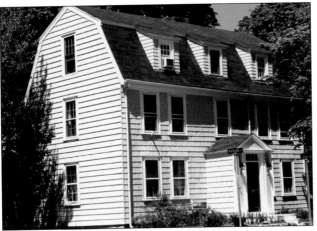

The Jonathan Brooks House was built around 1781. Jonathan Brooks resided here until his death in 1847. The home is located at the corner of Woburn and High Streets, and is listed on the National Register of Historic Places. Jonathan Brooks was the father of Charles Brooks, Medford's first historian. (Courtesy of Medford Public Library.)

The Charles Brooks House was built around 1780. The home was known as "the Lilacs" because of its beautiful gardens. In 1855, Charles Brooks published *The History of Medford*, which showed his enthusiasm for his native town. Brooks, known as Medford's first historian, died in 1872 at the age of 76. This home is on the National Register of Historic Places.

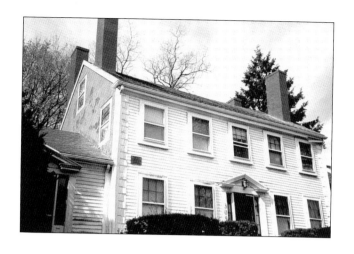

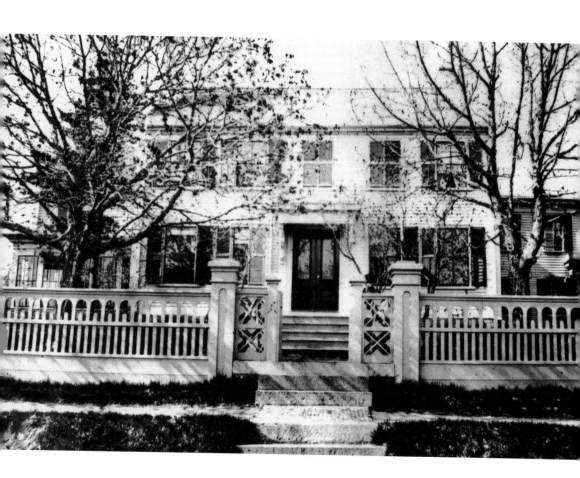

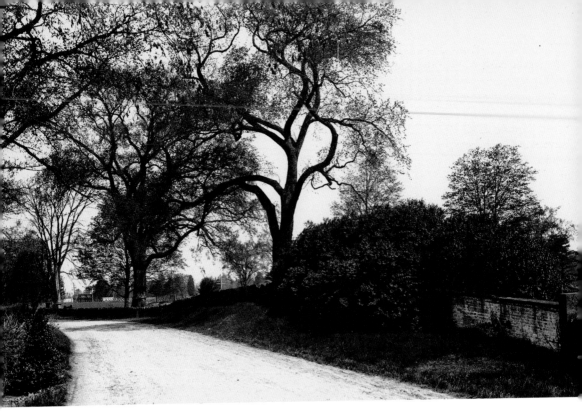

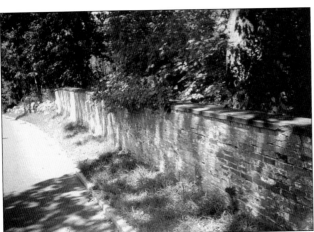

It has been claimed that the wall shown here was built around 1765 by Pomp, a slave owned by Thomas Brooks. The wall was built on Grove Street in West Medford. By 1765, there was a population of 49 slaves in Medford. In 1783, Massachusetts became the first state to abolish slavery. This brick and stone wall in West Medford, and the slave quarters in the yard of the Royall House, are the two remaining landmarks of slavery in Medford. (Courtesy of the Medford Historical Society.)

The West Medford Baptist Church, on the corner of Boston and Harvard Avenues, was built in 1897 and designed by Lewis H. Lovering. The building was first occupied on Easter Sunday, April 18, 1897, and Reverend Cambridge preached the service. Rev. Eugene Dolloff served his ministry here between 1931 and 1949. (Courtesy of the Medford Historical Society.)

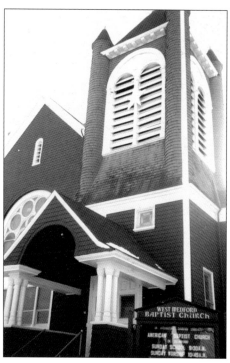

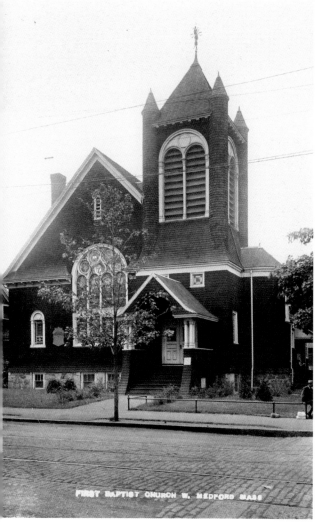

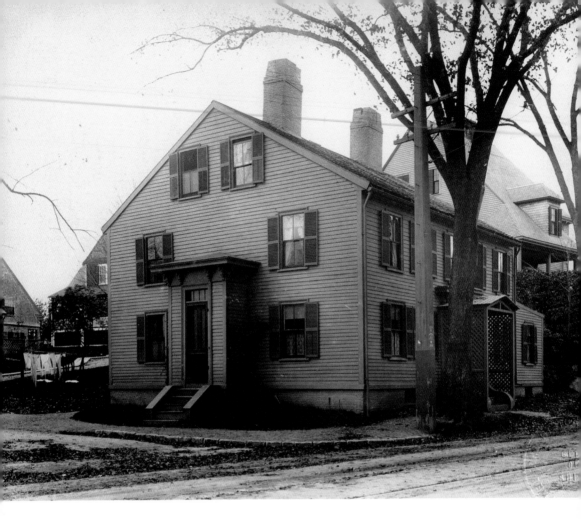

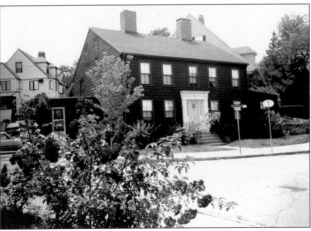

The John Bradshaw House in West Medford, believed to have been built prior to 1710, still stands on the corner of High Street and Hastings Lane. In 1702, John Bradshaw was chosen treasurer of the General Court of Assembly. The home was used as Medford's first meetinghouse, and it was here that the first church was organized in 1713. Bradshaw, along with many of the old family names such as Tufts, Francis, Blanchard, and Pritchard, represented the town's company of Minutemen.

The West Medford Congregational Church, located on the corner of High Street and Allston Street, was built in 1904. It stands as a memorial to Dea. Henry L. Barnes, fulfilling his desire for "an edifice worthy of the lot." It was remodeled in 1927 after fire damaged the interior. The church was originally formed in 1872, and the first building, which was dedicated in 1874, was on the corner of Harvard Avenue and Bower Street. In 1903, a fire destroyed the first building.

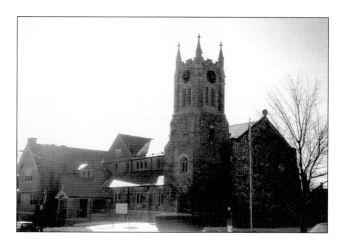

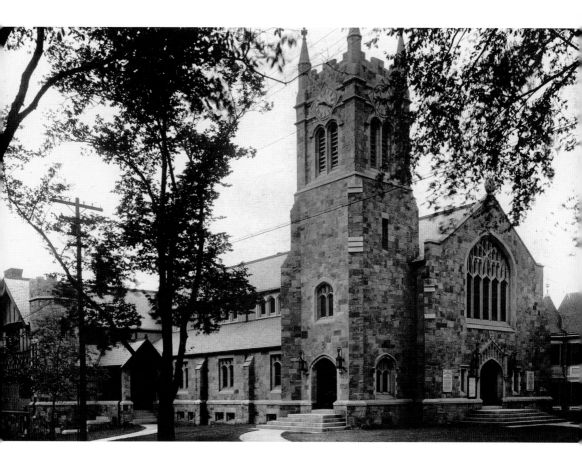

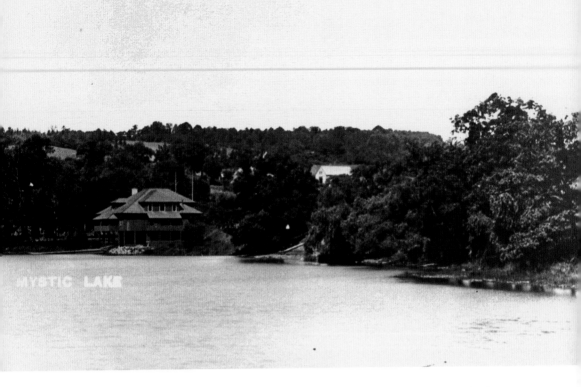

MYSTIC LAKE

In 1898, an organization was established to form the Medford Boat Club. The club's first clubhouse, finished in the spring of 1899, accommodated 36 canoes. Much of the canoeing took place in the upper portion of Mystic Lake. At the dawn of the 20th century, the club was prominent in racing and won many national championships. Today the Medford Boat Club on Mystic Lake still enjoys competitive racing and has a large membership.

This 1940s photograph of West Medford Square shows the A&P grocery store occupying Usher Block, which was built in 1883. The building next door houses a small Stop and Shop and the First National Store. Imagine three groceries on one block. The double-gable structure on the building's facade is visible in the modern photograph. (Courtesy of the Medford Historical Society.)

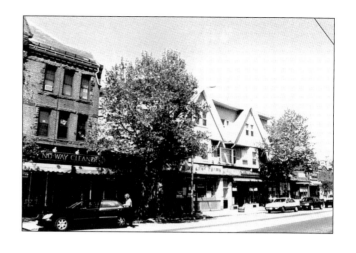

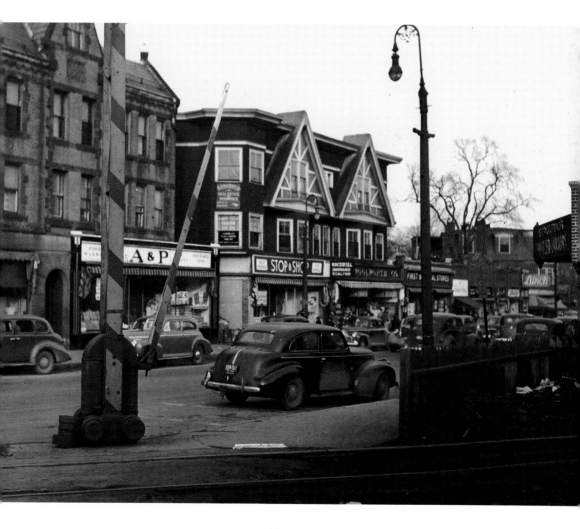

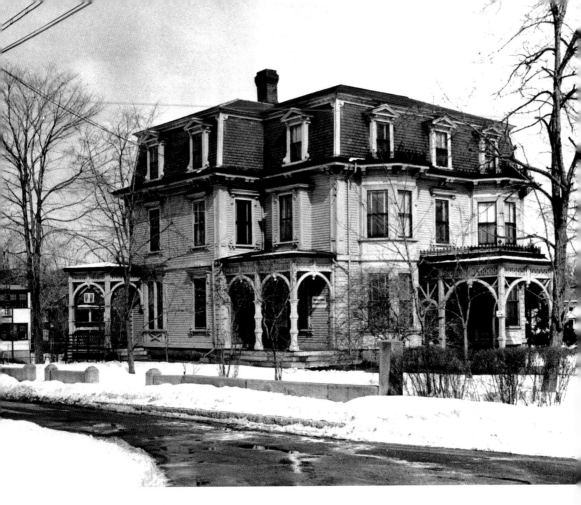

Before the end of World War II, an organization known as the Medford Jewish Community purchased a home on Water Street to provide a space to instruct children in Jewish tradition. The organization soon changed their name to the Medford Jewish Community Center. By the 1950s, a larger space was needed, and six acres on Winthrop Street was bought from the Metropolitan District Commission. The Water Street home was sold to the Police Athletic League. In 1958, the first service was held in the new temple. Recently, the Jewish Community Center at Temple Shalom was dedicated to William and Charlotte Bloomberg.

This is a photograph of the North Medford baseball team *c.* 1930. The North Medford club house was located on the corner of Fellsway West and Fern Road. This particular clubhouse also served the North Medford Marathon. Home games were played at Hickey Park. Phil Sanford managed the team and Chris Sarno hit home runs to left field, completely over the far side of the Fellsway trolley tracks. (Courtesy of Tom Convery.)

Chapter 4

NORTH MEDFORD

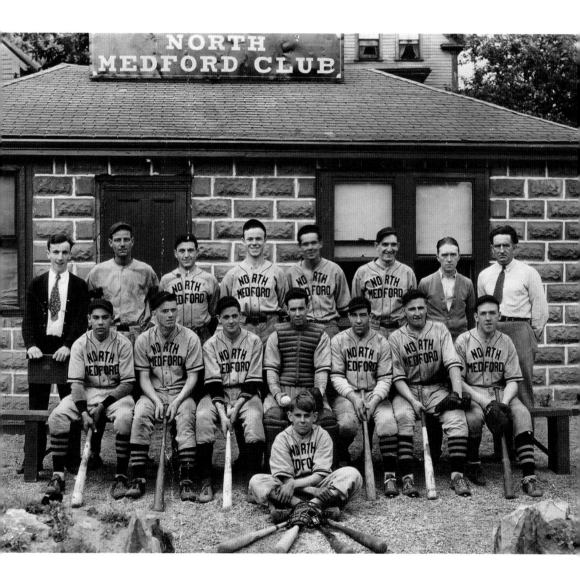

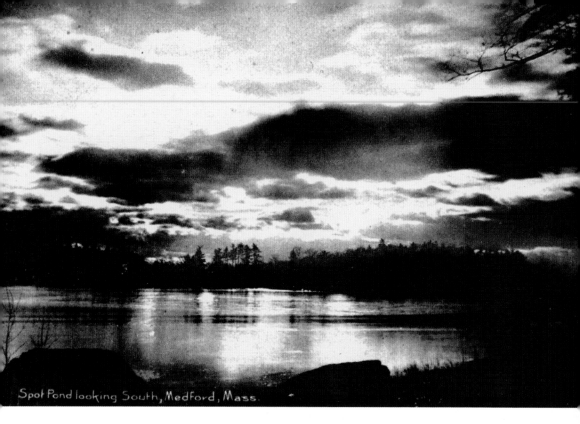

Spot Pond looking South, Medford, Mass.

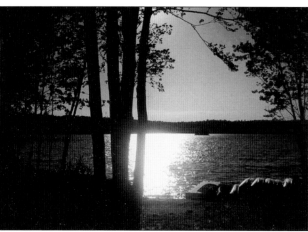

In 1870, Spot Pond was tapped as a drinking water supply reservoir for Malden, Melrose, and Medford. The pond, part of the Middlesex Fells, was once a hunting ground for Native Americans. By the 1800s, wealthy Bostonians would spend their summers on the banks of Spot Pond. Today the area is enjoyed by many visitors and the Metropolitan District Commission offers programs there for the public.

After much lobbying by local citizens, the Middlesex Fells became public parkland in 1894. One of these citizens was Elizur Wright, for whom Wright's Pond and the stone tower on Pine Hill are named. This vintage photograph, from 1954, shows the McCarthy family out for a Sunday walk in the woods. Today many people enjoy the reservation's 2,575 acres of terrain. (Vintage photograph by Joseph McCarthy.)

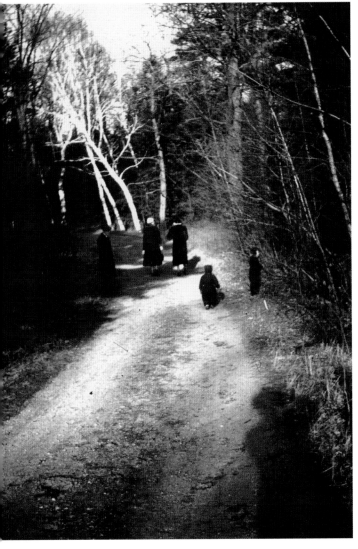

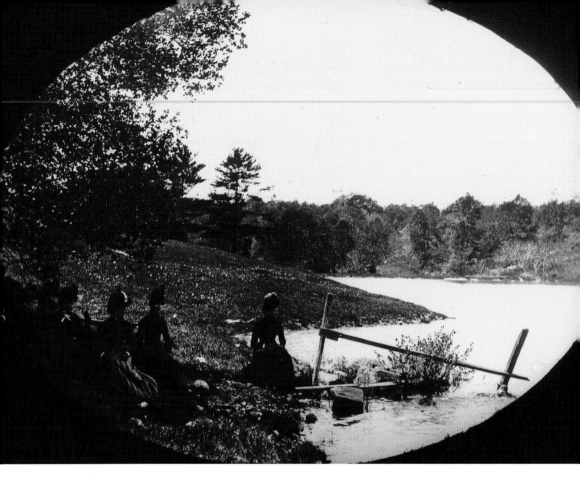

Wright's Pond is located on Elm Street in North Medford. It is named after Elizur Wright (1804–1885) who was often referred to as the "father of the Middlesex Fells." Medford residents have enjoyed this swimming and picnic reservation for generations. During the summer months, the pond is surrounded by beautifully kept gardens. (Courtesy of Medford Public Library.)

Visitors to the fells have always enjoyed many activities including hiking, biking, and jogging, as well as climbing Pine Hill to Wright's Observatory Tower. The tower, named after Elizur Wright, offers a spectacular view of Medford and the Boston skyline. The vintage photograph was taken in April 1946. (Courtesy of the Medford Historical Society.)

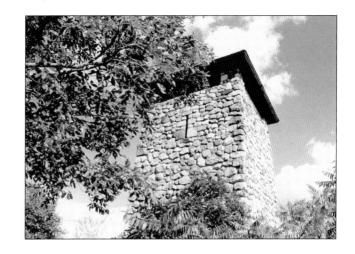

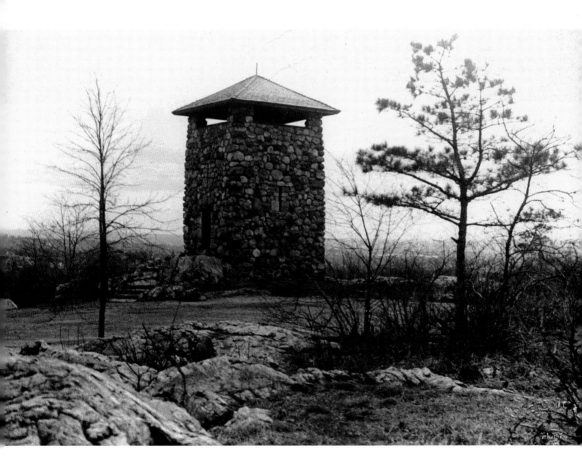

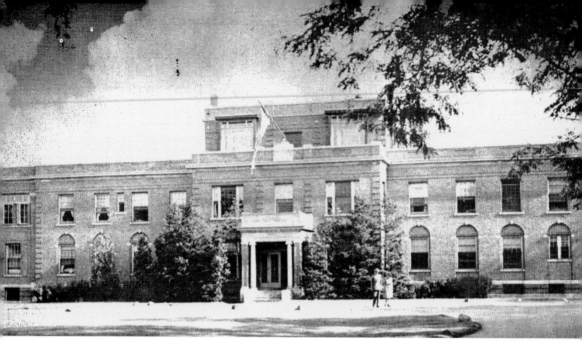

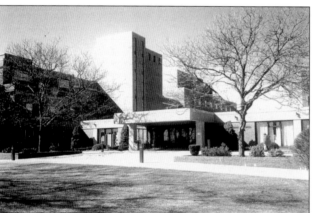

Carolyn Badger Lawrence, widow of Samuel C. Lawrence, donated eight acres of land on Governor's Avenue to build the Lawrence Memorial Hospital. The hospital opened its doors to patients on April 1, 1924. The adjacent nurse's residence was built in 1925. A two-story addition to the hospital was added in the late 1970s. (Courtesy of the Medford Historical Society.)

Once the home of Gen. Samuel
C. Lawrence, the first mayor
of Medford from 1893 to 1894, this
estate on Rural Avenue was 400
acres of farmland, gardens, and a
picturesque wooded area called
the Seven Hills. General Lawrence
constructed an observatory tower
on Rams Head Hill and owned a
farmhouse on the estate. Although
the tower and the beautiful home on
Rural Avenue no longer exist, the
farmhouse at the Lawrence estates
still stands and is privately owned.

Chapter 5

MEDFORD

SQUARE

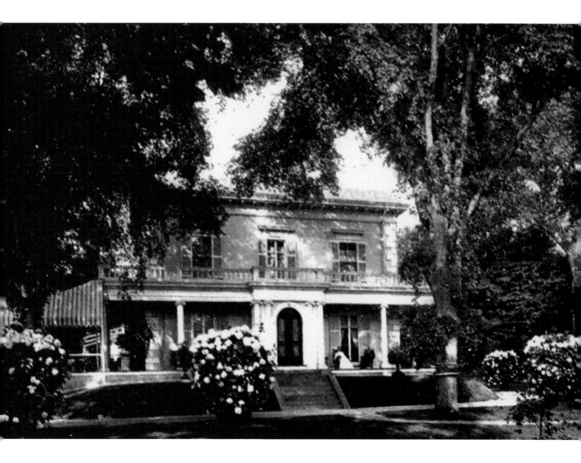

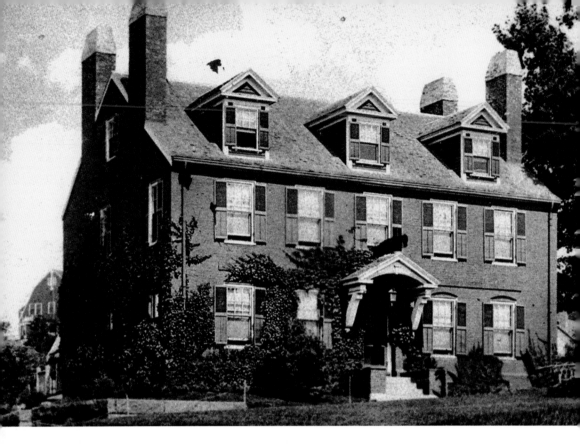

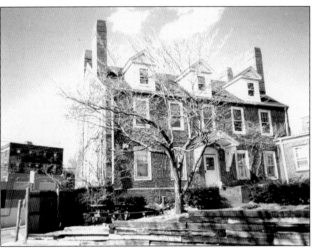

The Jonathan Wade House is located at 13 Bradlee Road. It was believed to have been built between 1683 and 1689. This house was sometimes called the "Garrison House" or "Fort," as was the Tufts–Cradock House, because of its thick brick walls. These homes were built as a refuge from Native Americans, although King Philip's War eliminated the danger from these attacks several years before. (Courtesy of the Medford Historical Society.)

Once the home of Capt. Andrew Isaac Hall, captain of the Medford Minutemen, this building was built in 1720, and stands at 45 High Street today. The vintage photograph was taken in 1890, and the contemporary photograph, taken in 2002, shows Gaffey's Funeral Home, which has occupied the historic building since 1913. There were four other Hall family homes along High Street. Three of those homes were razed, and the fourth, the Benjamin Hall Home, was moved to Mystic Avenue.

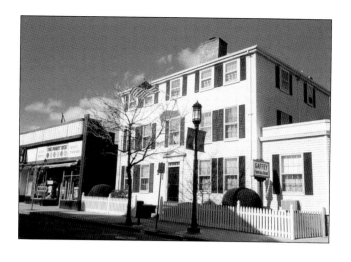

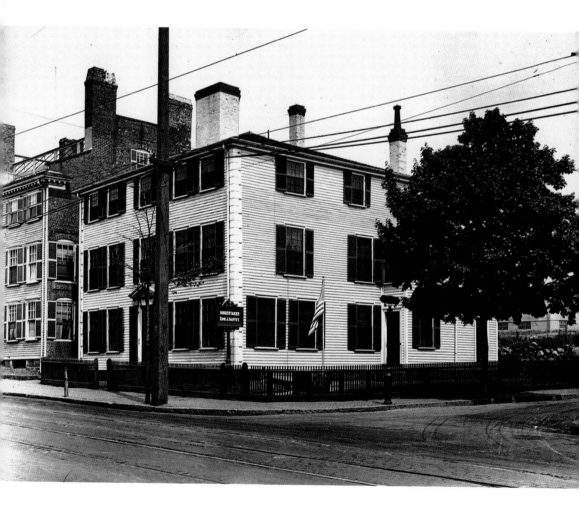

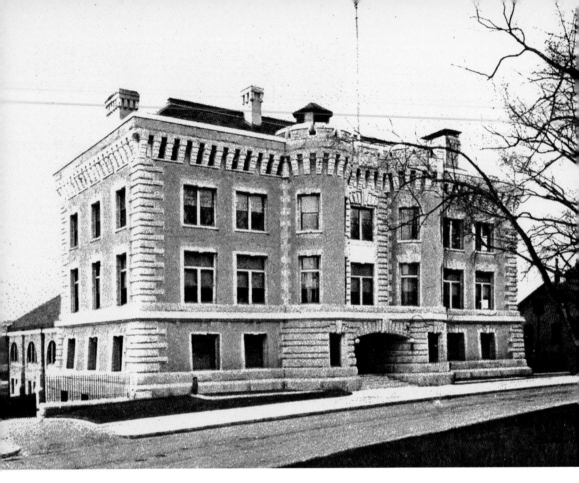

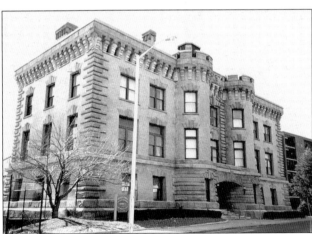

The Lawrence Light Guard Armory, located at 92 High Street in Medford Square, was built in 1901 by Gen. Samuel Crocker Lawrence to honor his father, Daniel W. Lawrence. It was built to house the Lawrence Light Guard Company E–Fifth Regiment. Once the National Guard unit moved to Reading, it became home to the Medford Masons. On Saturday nights during the 1960s, dances were held in the drill hall for Medford High School students and others in the area. Today the building is occupied by office condominiums.

The grocery store of P. Volpe and Sons was located in the Bigelow Block on the corner of Salem Street and Forest Street. The Volpes were in business for 65 years, beginning in 1885 and closing in 1950. The grocery was the first in the area to introduce the new Birdseye frozen foods. Currently, Dunkin Donuts and Farnam Insurance occupy the building. (Courtesy of the Medford Historical Society.)

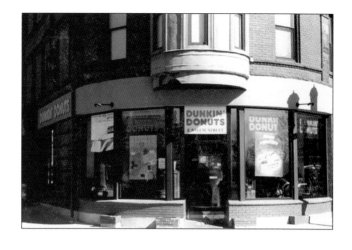

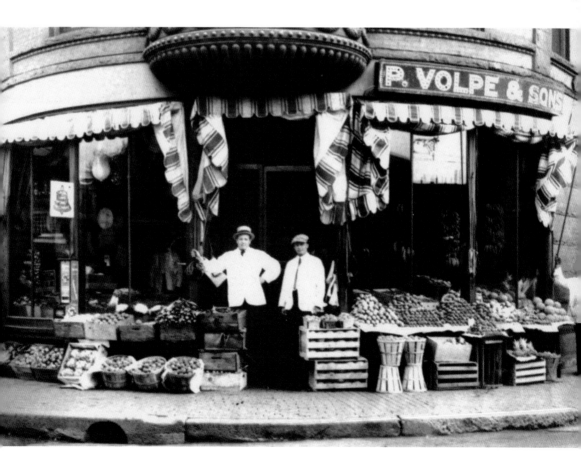

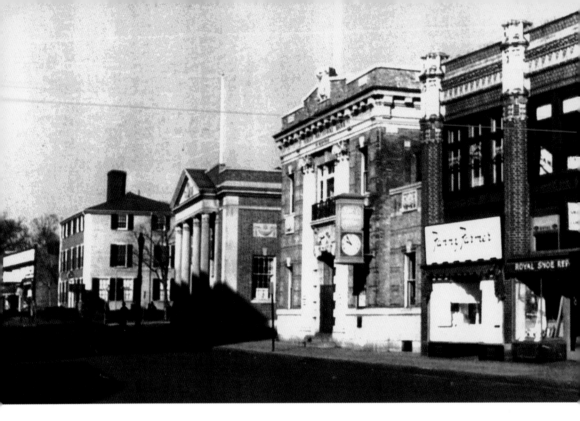

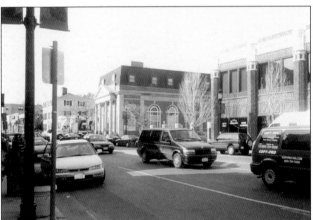

In this 1940s photograph of High Street in Medford Square, you can see Gaffey's Funeral Home, Medford Savings Bank, and the First National Bank of Medford. Also visible is the candy store, Fanny Farmer, which was the site of the former Simpson's Tavern. James Pierpont (1822–1893) composed the song "Jingle Bells" in Simpson's Tavern. In the recent photograph, the First National Bank of Medford has been razed to make room for a parking lot.

Dedicated on September 11, 1937, the new city hall was built on the site of the old Medford Common and the abandoned Everett School. The architect, Michael A. Dyer, also designed the Colonial Revival building at 36 Salem Street, which was the site of the Medford Theatre. Children pose in this early photograph from 1930 during one of Medford's holiday celebrations at the common. (Courtesy of Tom Convery.)

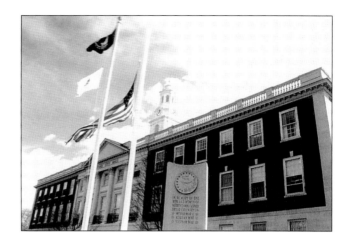

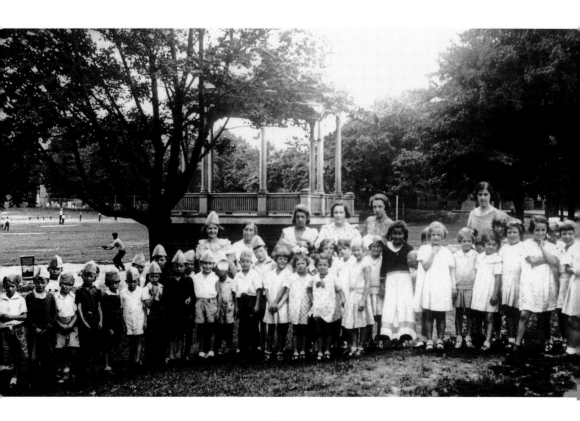

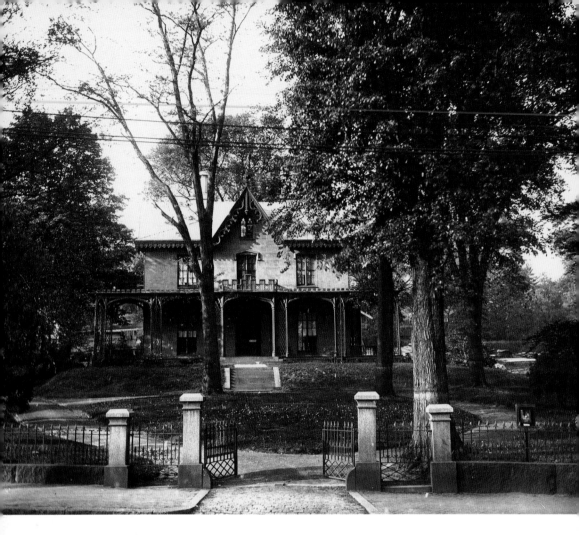

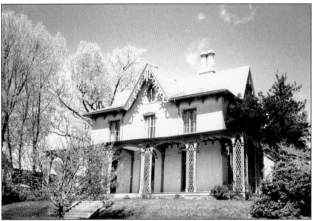

The John B. Angier House, built in 1842, stands at 129 High Street. John Angier came to Medford from Durham, New Hampshire. On May 1, 1821, Angier opened a boarding school for boys and girls on Forest Street. The home was once occupied by Mayor John Irwin from 1934 to 1937, and prior to that had been owned by the Boynton Family. This house is listed on the National Register of Historic Places.

Lepore Shoes was an important institution in Medford. It closed its doors in March 2004, after being in business for 73 years. Lorenzo Lepore opened the store in 1931. Eventually, the business was taken over by his son, Larry. In 1988, the store moved across the street on Forest Street. Larry, "the Sole Man," is now enjoying his retirement. (Courtesy of Larry Lepore.)

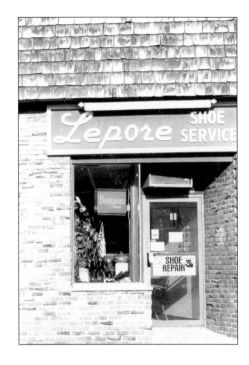

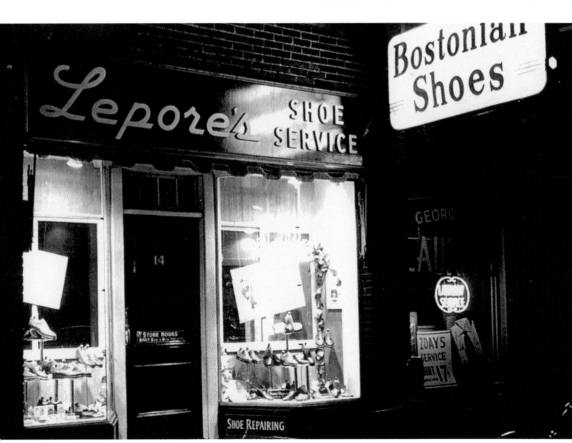

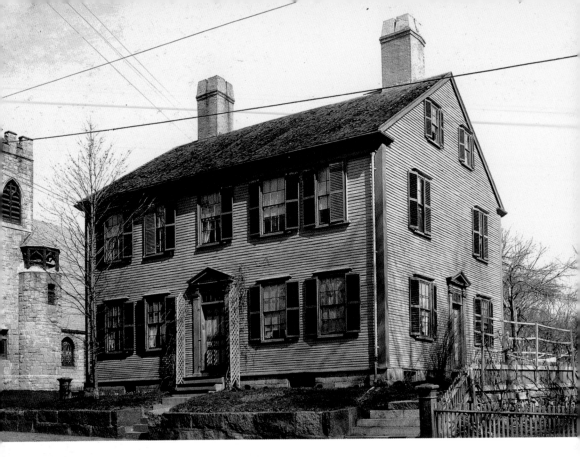

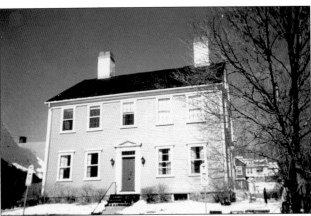

Rev. David Osgood built the Osgood House at 141 High Street in 1785. He died on December 12, 1822, at the age of 75, ending his ministry of more than 48 years. This home today serves as the parsonage for the Unitarian Universalist Church, which resides next door. It is also listed on the National Register of Historic Places.

The Unitarian Universalist church is located on the corner of Powderhouse Road and High Street. The Unitarian church was organized in 1658, and is the oldest church organization in Medford. The first Unitarian church was destroyed by fire in 1893. This building was dedicated on Friday, June 1, 1894. Currently the church is undergoing renovations. (Courtesy of the Medford Historical Society.)

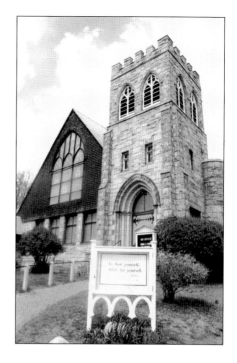

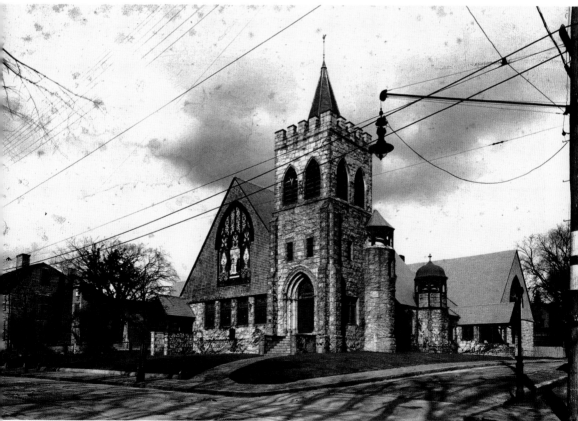

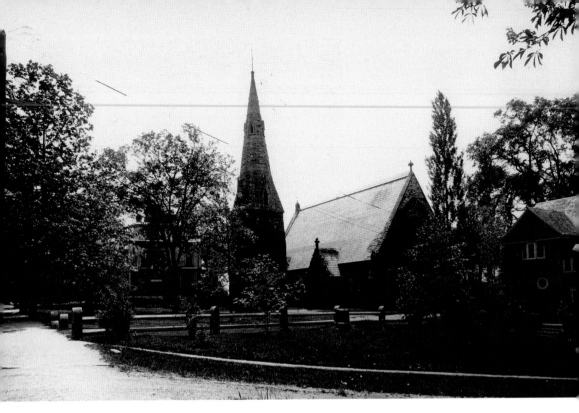

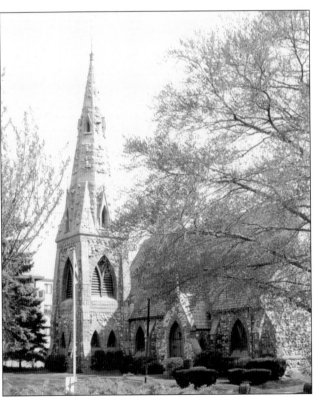

The Grace Episcopal Church at 160 High Street was built in 1872. The well-known architect H. H. Richardson designed it. The church was built with the financial help of Ellen Brooks. Originally her sons, Peter and Shepherd Brooks, owned the parish. By 1873, it was transferred to the parish. The Grace Episcopal Church is one of the most beautiful in the area, and is on the National Register of Historic Places.

This early photograph is a view of the Cradock Bridge, looking east from the Mystic Valley Parkway. The stone bridge shown here was constructed in 1880, after the shipyards went out of business. The Green Block at 32 Main Street is visible in both images. (Courtesy of the Medford Historical Society.)

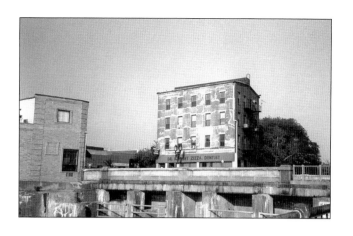

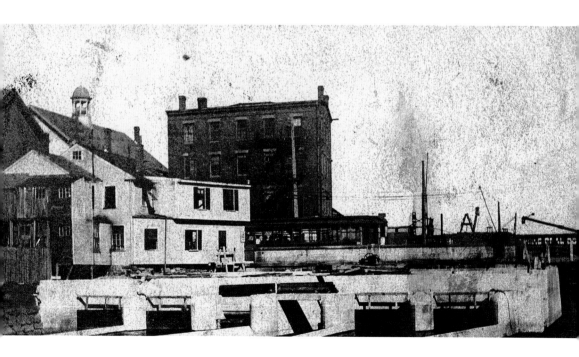

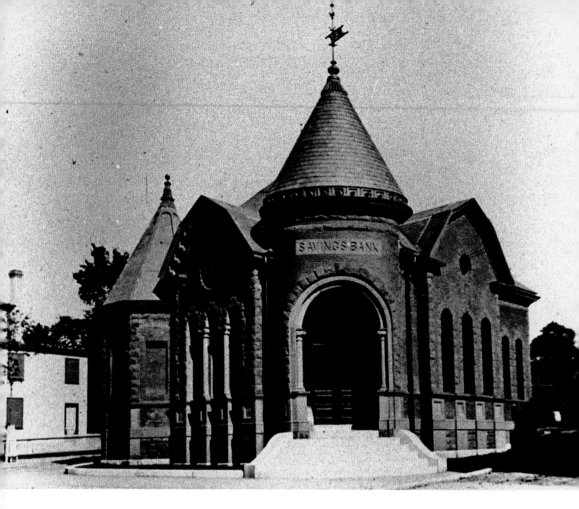

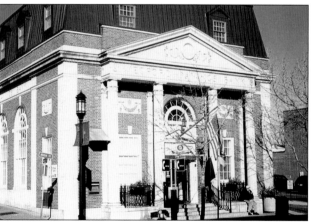

The Medford Savings Bank was organized in 1869. It was located on High Street in Medford Square, on the former site of the Governor Brooks House. This vintage photograph shows the bank in 1905. In 2005, the building was sold and will no longer be used as a bank, thus ending the long history of this establishment.

The birthplace of Lydia Maria Child, depicted in this old postcard, was the site of the first Medford Historical Society building. In March 1902, the society voted to buy the estate it occupied on the corner of Ashland and Salem Streets. Today the building is under construction, but in recent years it was a Chinese restaurant. It is next door to what was once the Medford Theatre and is now the Elizabeth Grady Salon.

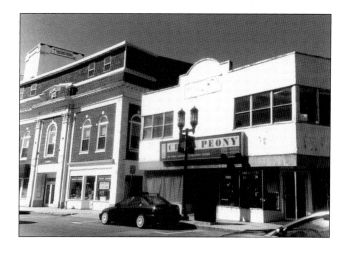

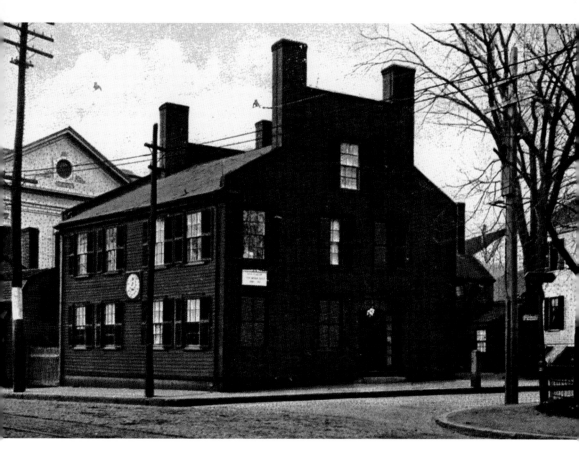

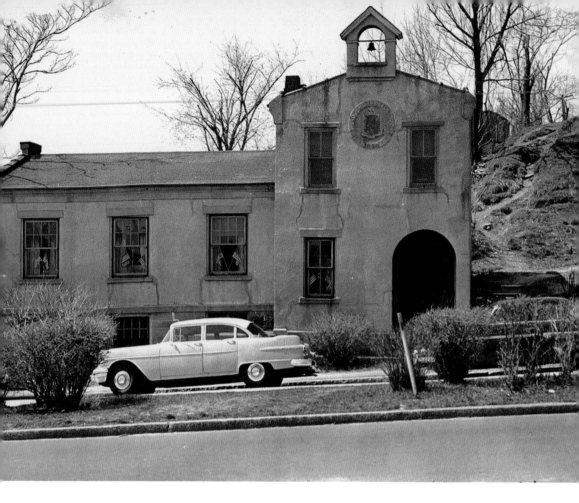

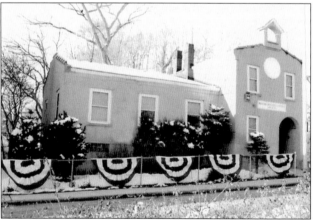

The Medford Historical Society was organized in 1896. On May 8th of that year, the first election took place, and William Cushing Wait was named president. The current historical society building, shown here on Governor's Avenue, was constructed in 1916 to accommodate over 1,000 bound volumes, which hold many manuscripts and pamphlets The vintage photograph shows the building in 1955, and the current photograph shows it in 2003.

Until 1849, there were no Roman Catholic public services in Medford. People had to travel to Cambridge to attend any services. A group of Catholics hired the town hall and a neighboring priest to conduct mass. By 1912, construction of St. Joseph's Church was completed. A parochial school was built in 1928 and by 1949 a convent was built. A new social center was built in 1963. Today St. Joseph's Church is widely attended.

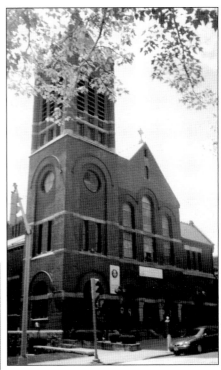

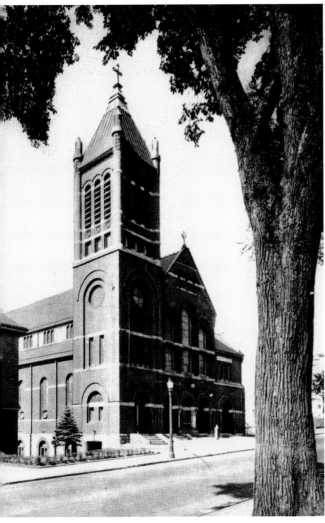

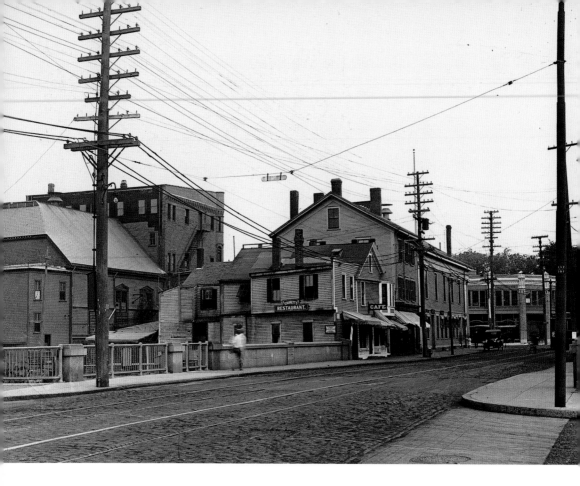

It is believed that the original Cradock Bridge was constructed around 1674. It was built across the Mystic River, close to Governor Cradock's farmhouse, Meadford House. In the photograph from 1916, you can see the intersection at Main Street, looking north towards Medford Square. The contemporary photograph was taken at the same vantage point.

The footbridge, or pedestrian bridge, over the Mystic River was built in 1898. It is located behind Medford Square. Both of these photographs were taken from Cradock Bridge, looking west. This picturesque scene has been painted and photographed many times and is a favorite with artists. (Courtesy of the Medford Historical Society.)

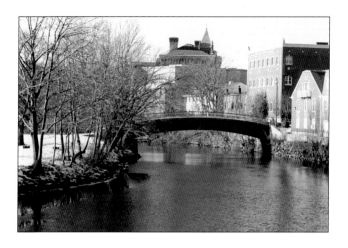

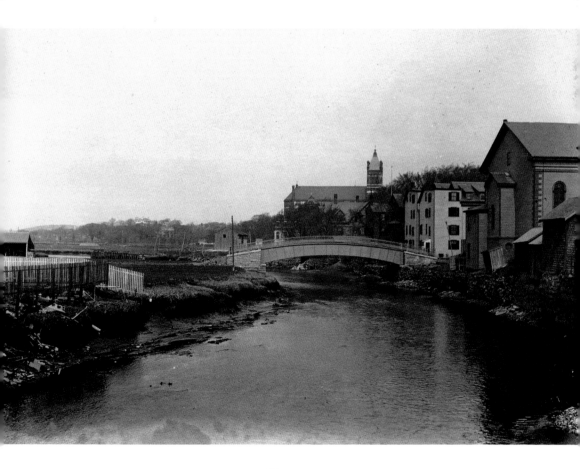

For two centuries, the Hall and Lawrence families distilled rum on Distill House Lane, now called Riverside Avenue This fine rum was made until 1905. In the vintage photograph, the house on the right is the Richard Sprague Home. It was on the corner of Dead Man's Alley, a path that led to Salem Street Burying Ground. Today that path is River Street. (Courtesy of the Medford Historical Society.)

The old Medford Public Library, located on High Street, was originally the Thatcher Magoun Mansion. In 1875, Thatcher Magoun Jr. offered his father's mansion to the town for a library. Over the years, branch libraries were located in many different parts of the city. Sadly, in 1959, the city decided that a newer, more modern building was more fitting for the main library. The Thatcher Magoun Mansion was demolished, and the new library was dedicated in 1960. In 2005, the Medford Public Library will celebrate its 150th anniversary.

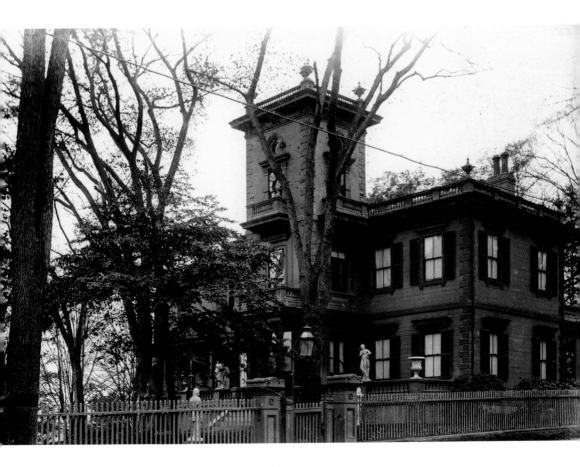

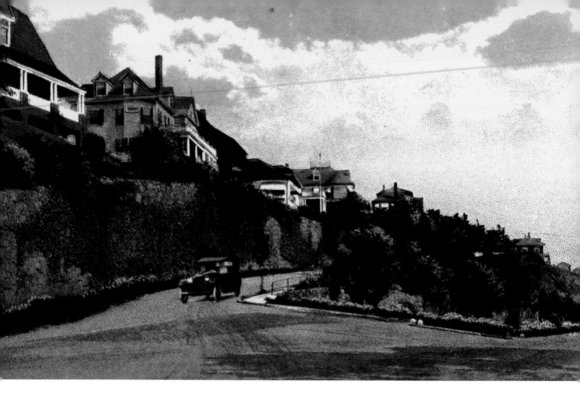

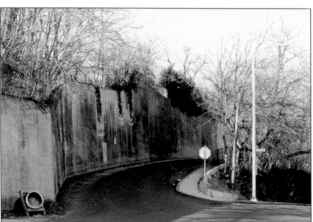

The retaining wall on Terrace Road was built in 1892. Terrace Road is located off of Governor's Avenue, and is a short distance from Medford Square. Governor's Avenue was constructed in 1892 and is named after Governor Brooks, one of Medford's finest citizens. As apparent in these then and now photographs, not much has changed over the years. (Courtesy of the Medford Historical Society.)

This building, on the corner of High Street and Main Street, is located on the site of the first city hall, which was razed in 1916. For a 21-year period, city officials rented various municipal spaces until the new city hall was built in 1937. In this 1935 photograph, the old city hall building is occupied by small stores and restaurants on the first floor and offices on the second floor. Today ERA Andrew Realty and Il Faro Restaurant occupy the building.

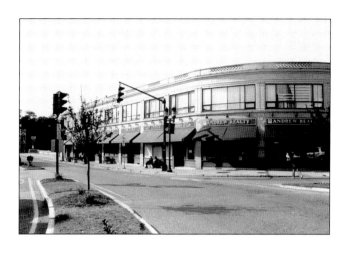

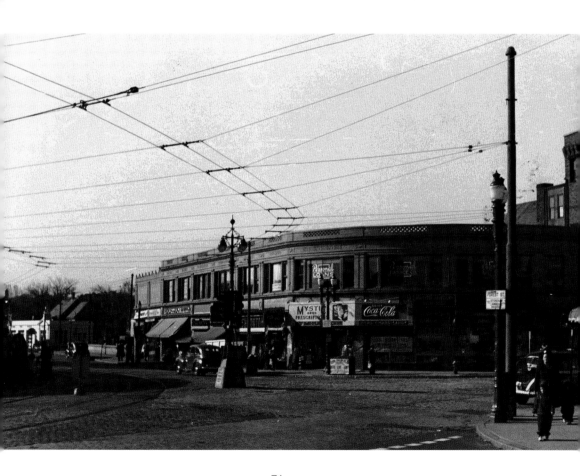

This intersection in Medford Square has been a favorite spot to photograph over the years. On the left side of the vintage photograph you can see part of the Medford Café and Liggett's Pharmacy, which were two popular establishments during the 1930s and 1940s. Currently, there is a master plan to revitalize the downtown area, which proposes a change in traffic patterns and the building of retail space and cafes along the Mystic River.

On December 19, 1955, Car 35748 was the last streetcar to leave the Salem Street carbarns. This ended 61 years of streetcars operating out of the Salem Street yards. Pictured waving goodbye in this vintage photograph are, from left to right, Rep. Thomas Doherty, Mayor Arthur Della Russo, Massachusetts Speaker of the House of Representatives Michael Skerry, starter Thomas Kevill, and City Councilor Patrick Skerry. (Courtesy of Tom Convery.)

Chapter 6

EAST MEDFORD

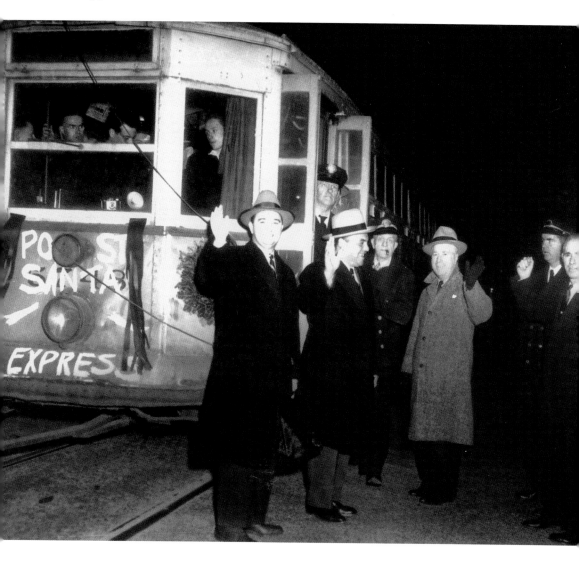

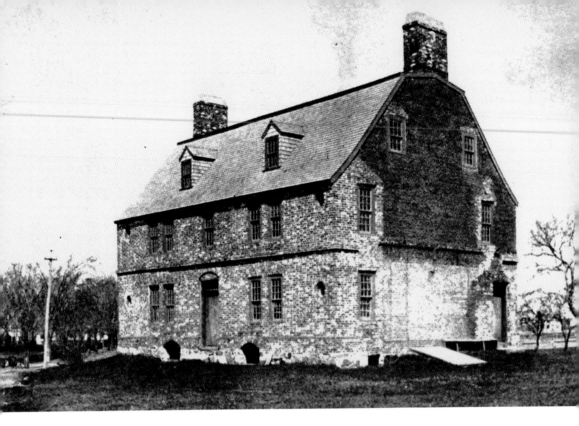

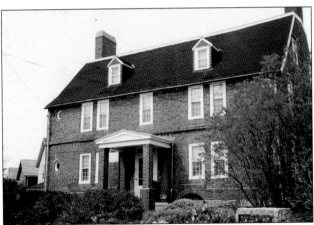

There are only two brick houses over 300 years old remaining in Medford today. The Tufts-Cradock House, located at 350 Riverside Avenue, is one of them. The Tufts-Cradock House is believed to have been built in 1634 for Governor Cradock. The land was sold to Peter Tufts around 1677, and then to his son in 1680. With its gambrel roof and small porthole size windows, it is the oldest building of its kind in the United States. Currently, the home is under the care of the Medford Historical Society.

This 19th century photograph of Spring Street, looking north towards Washington Street, shows the crossing of the Medford branch of the Boston and Maine Railroad. The home that was once the gatekeeper's is on the right side of the photograph. The apartment building on the left, though slightly altered, looks very similar today. (Courtesy of the Medford Historical Society.)

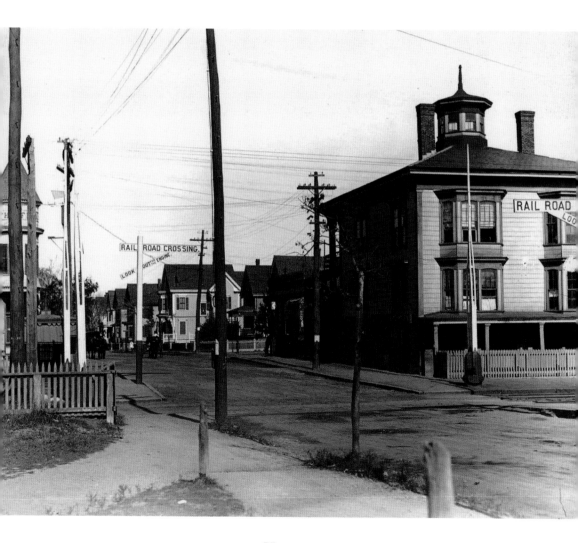

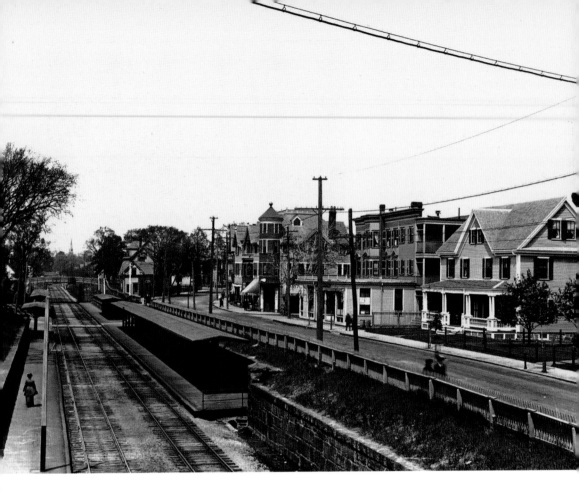

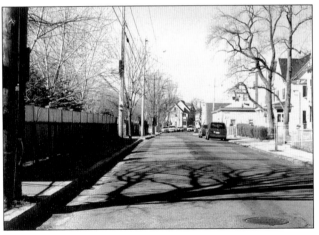

This vintage photograph shows Washington Street and part of the Park Street Depot platforms. The Park Street Depot was located on the Medford spur that connected Medford Square to the main branch of the Boston and Maine Railroad. A similar view, taken in 2002, shows some of the same houses that can be seen in the older photograph. (Courtesy of the Medford Historical Society.)

The intersection of Spring and Salem Streets is shown here around 1940. On the left of the photograph is where the Fellsway Theatre was located. Anthony's Liquors and a variety store occupy that space now. The building however has the same façade as the old theater. Modern Hardware now occupies the site where the A&P once was. (Courtesy of the Medford Historical Society.)

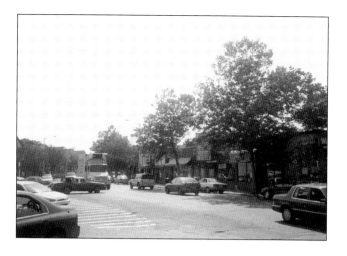

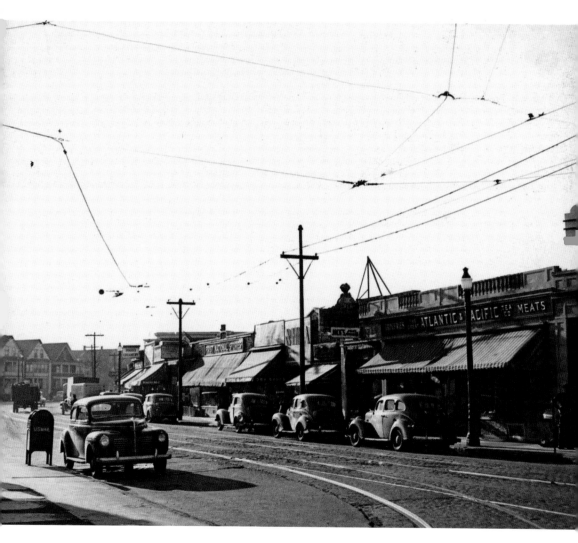

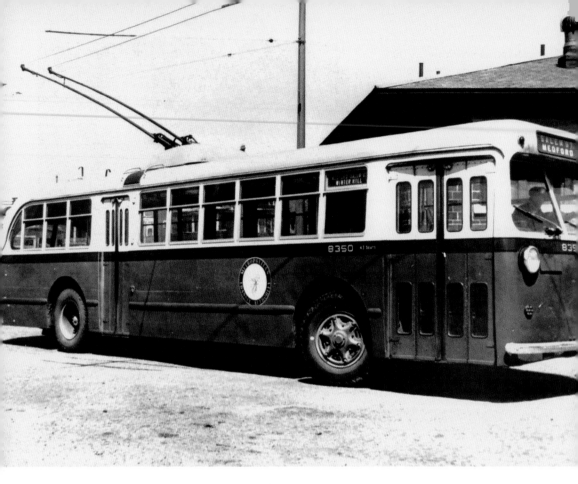

This 1950s-era photograph shows the electric trolley bus in front of the old waiting station on Salem Street in Haines Square. These trolley buses were in use between 1947 and 1959. The route took passengers to Sullivan Square, Medford Square, and Salem Street. It was Medford's only electric bus route. (Courtesy of Tom Convery.)

This 1910 photograph shows the Park Street Depot on Magoun Avenue. Years later, the building was used as a private club called the Redskins. In modern times, it is the Community Family Alzheimer's Day Care Center. For the past several years, the Jingle Bell Festival committee has raised money for the center by raffling decorated Christmas trees that were donated by local businesses and residents. (Courtesy of Medford Public Library.)

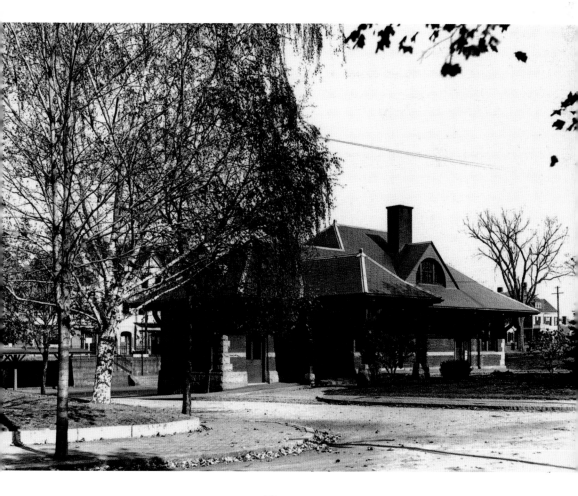

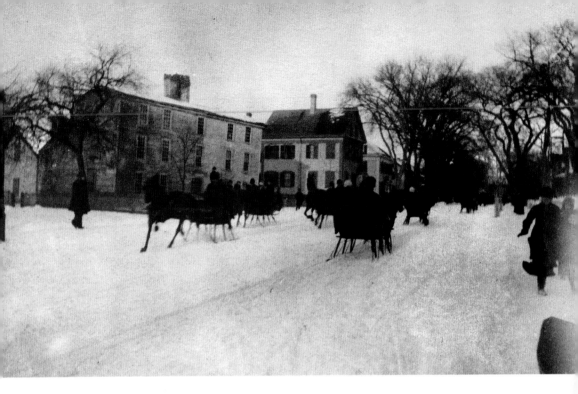

In this 19th century photograph, residents of Medford enjoy sleigh rides on Salem Street. The home on the left is the Fountain House, which was built in 1713. At that time it was used as a tavern. The Fountain House was demolished in 1887. It is easy to see where James Pierpoint got his inspiration from while composing "Jingle Bells." This northeast section of the city was divided with the construction of Route 93 in the early 1960s. (Courtesy of Maia Henderson.)

Medford is well known for its pomp and ceremony. For many years, parades and celebrations have been common, especially around Memorial Day and the Fourth of July. Memorial Day parades have been celebrated in Medford since 1912. On September 20, 1930, Medford celebrated its 300th anniversary. In this photograph, dated from the 1950s, a parade heads east down Salem Street. Notice the Potter Building on the left. (Vintage photograph by Joseph F. McCarthy.)

Chapter 7

CELEBRATIONS AND SCHOOLS

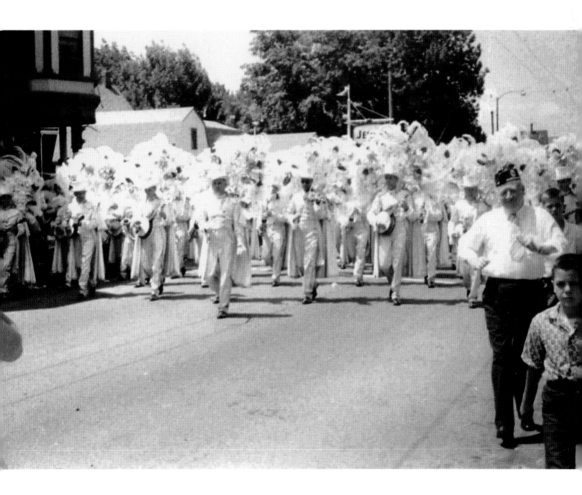

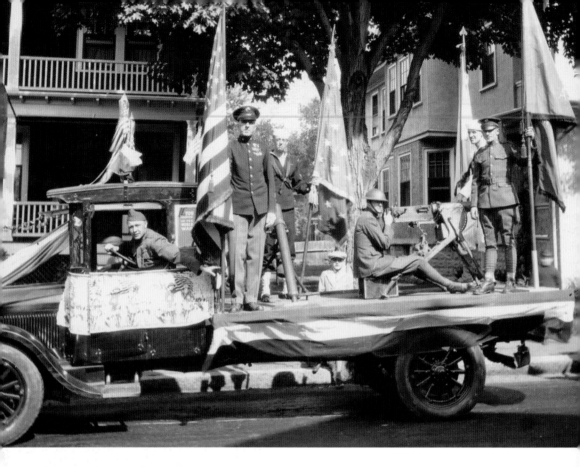

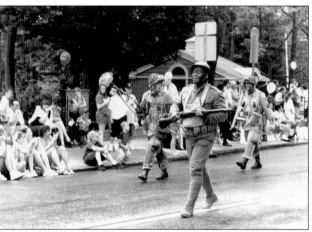

This early photograph from 1921 shows World War I veterans on a float in a Memorial Day parade. The modern photograph, taken in 2003, shows soldiers in World War II attire marching down High Street towards Medford Square. (Courtesy of the Medford Historical Society.)

The Medford High School band has performed for many years for football games, and on Patriots Day (or Paul Revere Day) and Memorial Day. In this July 4, 1937, photograph, the Medford High School band marches down High Street in Medford Square. Drum major Robert Mullis leads the band. In the modern photograph, the high school band performs at Oak Grove Cemetery on Memorial Day, 2004. Notice how the uniforms have changed over the years. (Courtesy of the Medford Historical Society.)

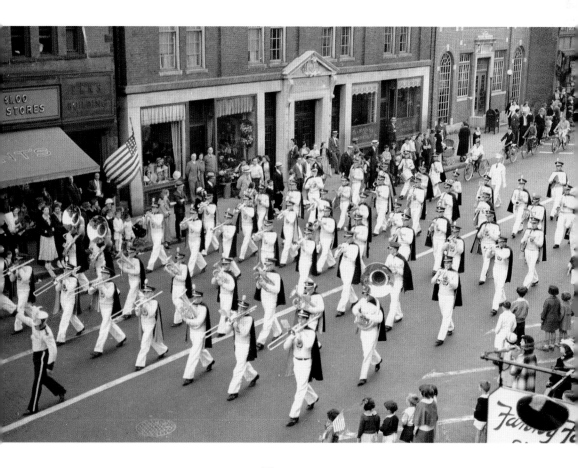

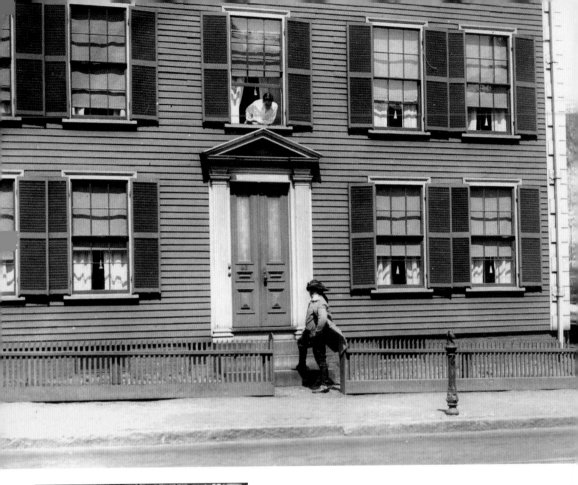

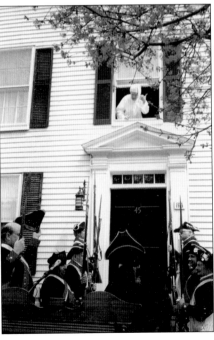

A reenactment of Paul Revere's ride, which warned local citizen's that "the British were coming," has been performed on Patriot's Day in Medford since 1914. This modern photograph shows Tom Convery of the Salem Street Business Association playing Capt. Andrew Isaac Hall in nightcap and gown. The home pictured is Gaffey's Funeral Home on High Street (Courtesy of Medford Public Library.)

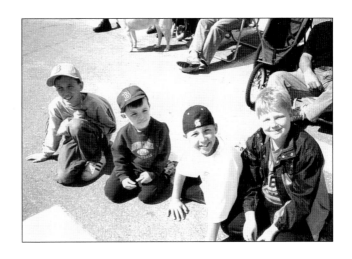

Except for the boy in the suspenders, most of the children in this photograph from the 1950s seem captivated by the float passing by in a Fourth of July parade. The three children in the foreground are, from left to right, Joe McCarthy, Betty McCarthy, and Christine O'Hearn. The 2000 photograph shows, from left to right, Chris Grant, Teddy True, Michael McCarthy, and Michael Hobbs, waiting in anticipation for a parade to begin. (Vintage photograph by Joseph F. McCarthy.)

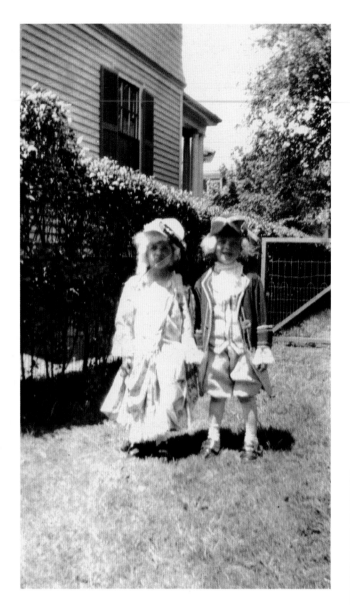

In 1930, the *Pageant of the Mystic*, written by Ruth Dame Coolidge, was performed at the Shepherd Brooks Estate in West Medford. Mayor Edward Larkin chaired this event. Two young children, Ted and Margaret O'Hearn, participated in the pageant and are shown in this picture. In the photograph taken in 2004, the three youngest granddaughters of Margaret O'Hearn are pictured dressing up in their own costumes.

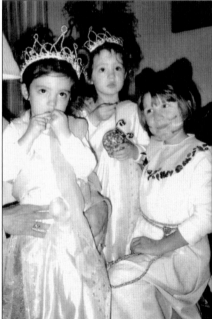

Mayor Edward Larkin, chairperson of Medford's tercentenary celebration, is seen here greeting local citizens dressed in period costumes at the Shepherd Brooks Estate on June 14, 1930. Pictured from left to right are, Mrs. J. D. Robinson, Mrs. Hollis E. Gray, Mayor Larkin, Edwin F. Pidgeon as "Governor Winthrop," Elizabeth L. McGray, and Mrs. Forrest O. Batchelder. The modern photograph shows Mayor Michael McGlynn speaking at the May 2004 Memorial Day service at Oak Grove Cemetery.

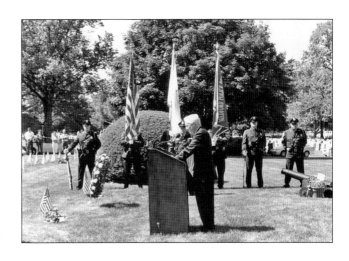

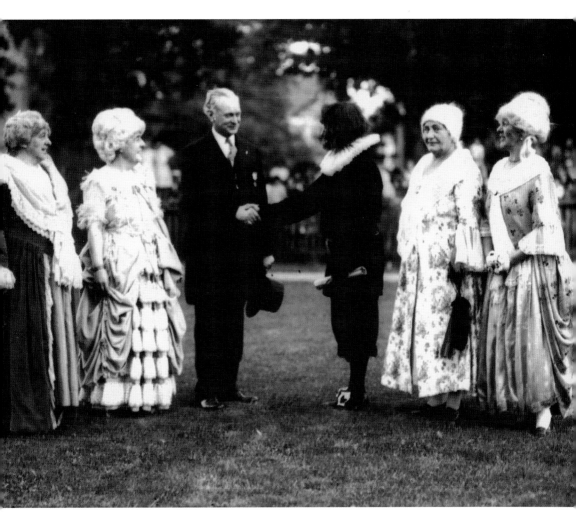

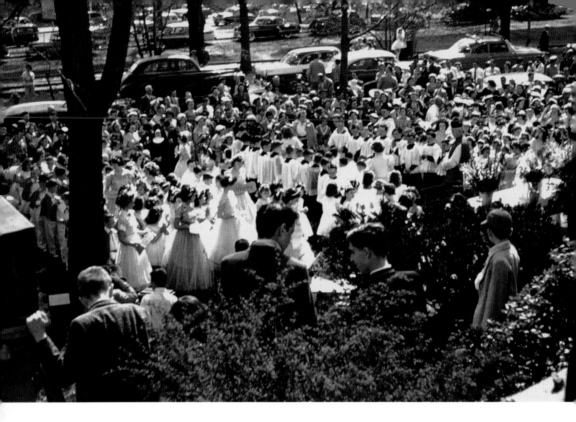

In June 1921, St. Francis of Assisi parish was established in North Medford. The first public mass was celebrated in the new church on December 8, 1921. In March 1949, Rev. William B. Foley became the new pastor and immediately made plans to establish a parish school. By June 1958, St. Francis of Assisi School graduated its first class of 36 girls and 32 boys. During the 1950s and 1960s, the parish had many memorable celebrations, and most people who attended the school remember the colorful May processions. Through these May processions, the girls in each grade wore different color dresses and were led by an 8th grader. Boys wore suits, and if you were in the second grade, you dressed in your communion attire. The procession would eventually end in front of the statue of Mary on the Fellsway West. The modern photograph was taken at the same location on a quiet Sunday afternoon. (Vintage photograph by Joseph F. McCarthy.)

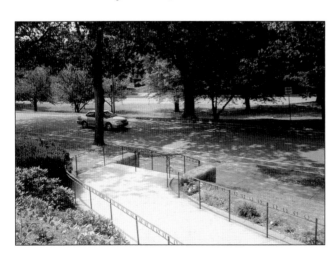

Page and Curtin, a supplier of household goods and plumbing fixtures, displayed their supplies on a float during the Fourth of July parade in 1894. You can see Tufts Hall on the right draped in flag buntings and on the left is a granite horse trough that replaced the old town pump. The recent photograph was taken on a quiet Sunday afternoon at the same location. (Courtesy of Medford Public Library.)

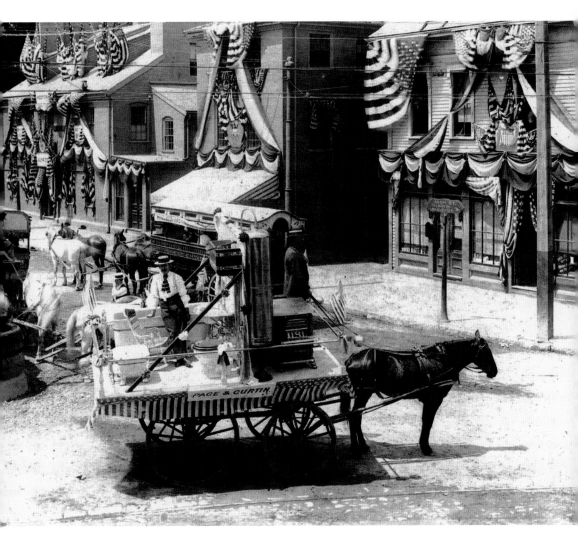

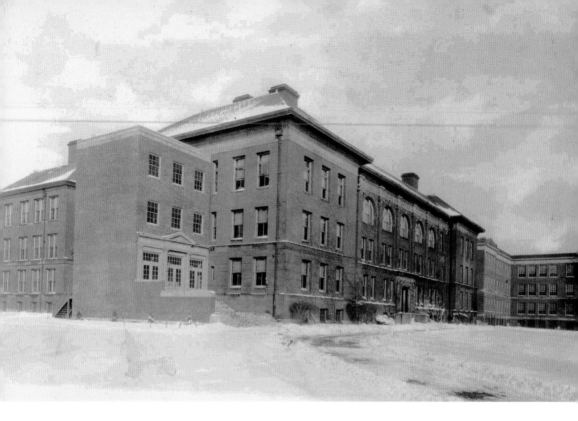

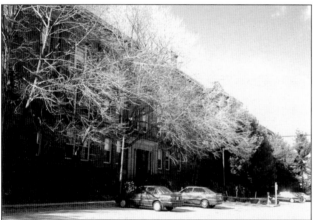

The first Medford high school opened in May 1835. It was a single room of the one-story brick grammar schoolhouse built in 1795 in the rear of the Unitarian church. Later a new high school was built on Forest Street. It was dedicated in May 1896, in honor of Rosewell B. Lawrence, chairman of the school committee. In 1965, a fire started in the boiler room that destroyed two of the high school's central buildings. Students at that time had to attend double sessions. Soon there were plans to build a new high school on city land off of Winthrop Street. In September 1970, classes started at the new high school. In modern times, condominiums occupy the old high school.

In September 2001, two buildings were constructed on the Metropolitan District Commission property known as Hormel Field. These two buildings were the Madeline Dugger Andrews Middle School and the John J. McGlynn Sr. School. This was phase one of the Medford school revitalization plan. Phase two of this plan was to replace three older public schools. One of these schools, the Brooks–Hobbs Middle School, was replaced by the new Brooks Elementary School in West Medford. The Brooks school has occupied three different houses since it was organized. The first school was located at the corner of Brooks and Irving Streets. The second building stood on the same site of the present school. In the old postcard

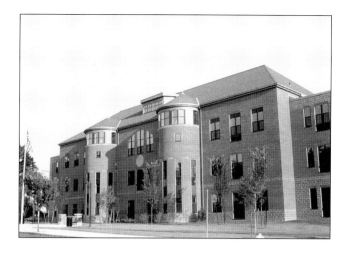

is a photograph of the old Brooks school in 1908. The new Brooks school opened its doors to students in September 2003.

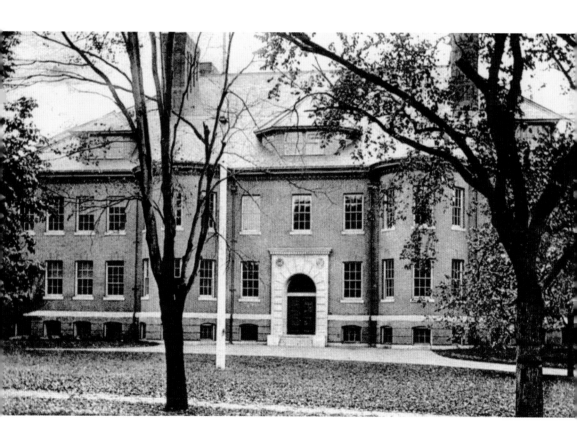

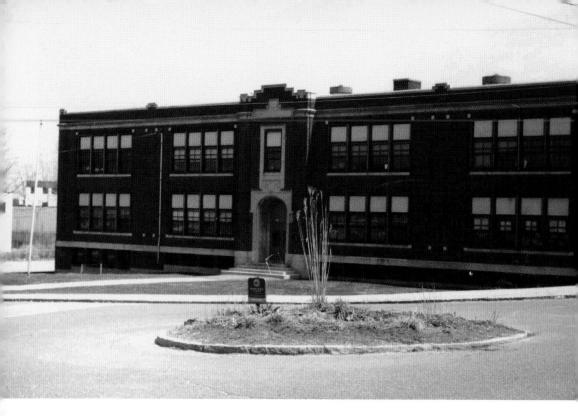

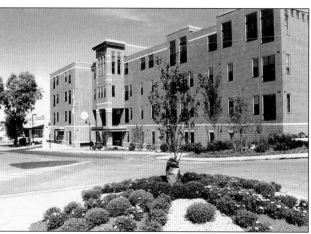

In 1927, a lot was secured at the junction of Hicks Avenue and East Albion Street to build a school. The school committee wanted to name it "Mystic," but Italian-American citizens in the district requested the name be changed to Christopher Columbus School. The petition was granted, and the school opened in the fall of 1929. This school, a part of the Medford school revitalization plan, was replaced by a new Christopher Columbus School in September 2003.

R oberts Middle School, which was located in northeast Medford, was named for Lt. Milton F. Roberts, in honor of his service in the Civil War, Spanish-American War, and World War I. The dedication and public inspection for the school occurred on March 18, 1928. In September 2003, Roberts Elementary School replaced Roberts Middle School.

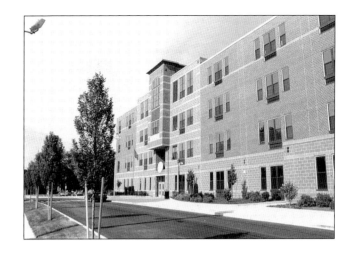

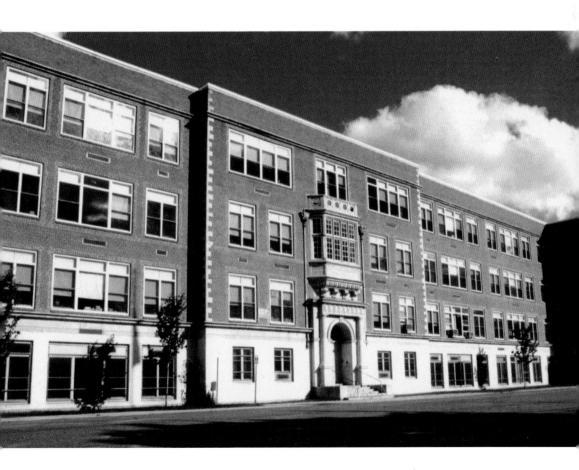

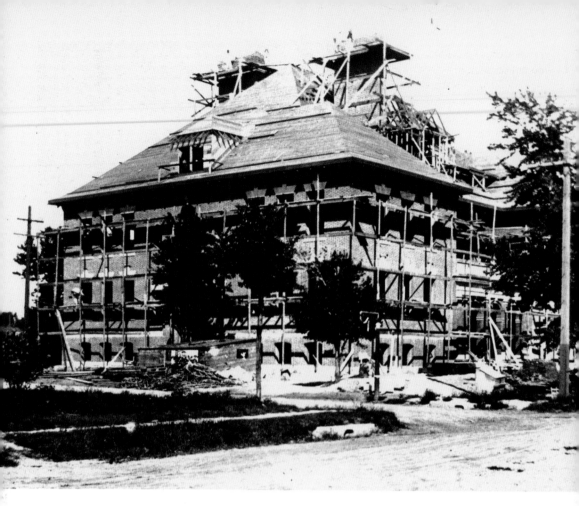

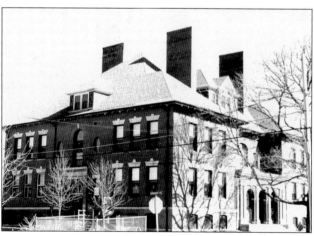

The lot where the Franklin School stood was originally purchased in 1896. The school was ready for occupancy in September 1900, and Bliss P. Boultonhouse was its first principle. Around January 2001, Mayor McGlynn formed a school reuse committee to determine the future of the remaining old schools. Recently developers bought the school and will most likely turn the building into condominiums.

The two-story, four-room, wooden schoolhouse shown in this vintage photograph stood from 1855 to 1916. It was replaced by Swan Junior High School, which occupied the lot from 1918 to 1927. Swan Junior High School later became an elementary school. The Swan School is now empty, waiting for renovation and occupancy. In 2004, a group of artists wanted to buy the building for an arts and cultural center but the idea was voted down by the city council.

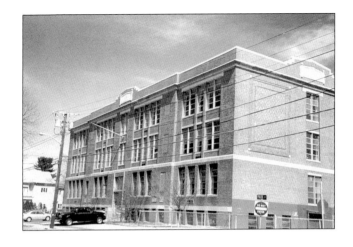

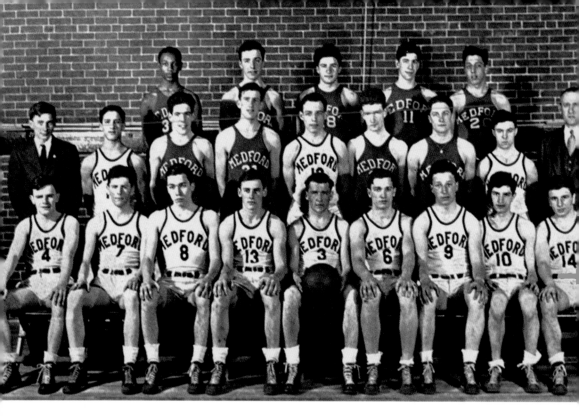

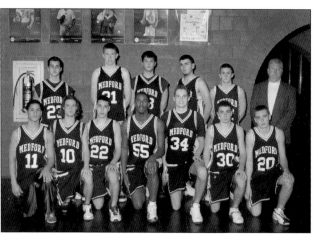

In 1940, the boy's basketball squad consisted of 21 players, one captain, a coach, and a manager. They played 13 games, won six and lost seven. Shown here in 2004, the varsity basketball team, called the Mustangs, pose for their yearbook photograph. The 35-year-old Medford High School and Vocational School is part of the city's ongoing renovation plans. The plan calls for making necessary repairs, improvement, and upgrades to the facility. (Contemporary photograph courtesy of Terry Bleiler.)